CW00547654

PICKERING
THROUGH TIME

Gordon Clitheroe

AMBERLEY PUBLISHING

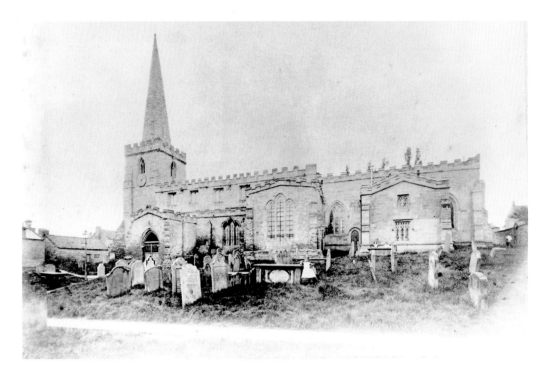

This photograph of St Peter and St Paul parish church was thought to have been taken in the 1890s by local photographers Boak and Son, who had studios in Bridlington Quay, Malton and Pickering. Note the lack of trees in the churchyard, and the small girl near the tombstone.

First published 2009

Amberley Publishing Plc
Cirencester Road, Chalford,
Stroud, Gloucestershire, GL6 8PE

www.amberley-books.com

Copyright © Gordon Clitheroe, 2009

The right of Gordon Clitheroe to be identified as the
Author of this work has been asserted in accordance with the
Copyrights, Designs and Patents Act 1988.

All rights reserved. No part of this book may be reprinted
or reproduced or utilised in any form or by any electronic,
mechanical or other means, now known or hereafter invented,
including photocopying and recording, or in any information
storage or retrieval system, without the permission in writing
from the Publishers.

British Library Cataloguing in Publication Data.
A catalogue record for this book is available from the British Library.

ISBN 978 1 84868 551 2

Typesetting and Origination by Amberley Publishing.
Printed in Great Britain.

Introduction

When I moved to Pickering as a small boy in 1945, it seemed a magical place. Without the use of photographs it would be hard to believe the changes that have transformed the town. My new uncle 'Dicky' Dale, a wheelwright, would turn a heap of timber into a horse-drawn flat cart. He would make the wheels, fit the red-hot steel hoops, paint the woodwork, add decoration called 'stringing', then coats of varnish. It is difficult to describe the marvellous finished carts, made to order and used to sell fruit in the north of England. At the cattle market in Eastgate were sited the council depot, fire station and cattle ring. We would cheer the retained firemen as they raced to the fire station, then the crowd would cheer as the engine pulled out. We were called to the site by the wailing of the fire siren. On their return, the canvas fire hoses would be rolled out in the covered racks (the posts for these can still be seen in the car park wall, above the exit).

I would watch Wilf McNeil shoeing horses in his blacksmiths shop in Kirkham Lane. I would also have my hair cut at Fred Pickering's barber shop inside the Vaults, Market Place, and Jack Redman's in Park Street. Once I visited Dobson's Foundry in Coopers Yard on a school visit. A second foundry owned by the Fletcher brothers operated in Park Street. I also earned pocket money winding the crane handle in the railway goods yard, loading trucks with scrap metal. I have watched coal gas being made at the town's gas works, in Gas House Lane, where 'Jock' Manderson and others would rake out red-hot coke from the ovens called retorts (tramps would sleep on the warm coke at night).

Pickering Sawmills operated in Southgate, which was known to locals as the 'Czech Yards', while families paid the council five shillings per week to live in the former army camp known as the Squatters. I have used the rifle range inside the Drill Hall, now Cooper's Ironmongers, and also delivered bags of firewood to the elderly residents of Victoria Place in Eastgate. The cottages were two rows of brick dwellings, and consisted of one room downstairs, with a bedroom above, three water

stand taps outside, and a separate row of shared toilets at the bottom of the yard. They have been replaced with a fish and chip shop.

Then there was the coalyard and bone mill in Southgate and the tanyard buildings in Hungate. The town had two nurseries, Hallsworth's, and Roger's Nurseries in Whitby Road, and sand quarries at Newbridge. There were also tennis courts in Kirkham Lane, Malton Road, and Goslipgate. I have queued on a Saturday night to see films at the Castle and Central cinemas, and have also cheered wrestling matches in the Castle cinema and the old bowling green in Kirkham Lane.

Petrol pumps were sited outside the Drill Hall in Southgate, the Horse Shoe Garage in Hallgarth, and Roy Pickering's, Robin Frank's, and Fred Ford's garages, the last being in Eastgate, supplying fuel at the roadside. Brothers Jack and Dick Baldry would repair boots and shoes at their cobblers shop in Malton Road, while 'Dab' Kelsey sold fish and chips from his shop in Hungate. We even had two wooden kiosks selling sweets and tobacco, one in Bridge Street, run by Harry Wilson, and one in Eastgate between the Royal Oak public house and the United bus station. This was owned by the landlord Charlie McLaren, who refused to pay council rates on the shop. He fitted four wheels to the kiosk in order to make it mobile, and moved it each morning and evening on two short lengths of railway line. Dick Wood delivered furniture using his mule and rulley. The mule 'Ginny' would stop for a rest without any regard for motor traffic.

I have tried to show comparisons, which allows you to see what has happened to the same site, using colour photography. I hope that my love for the town comes across in the knowledge that I pass on to you. It is a first for me using colour photography. Enjoy the book and marvel, or weep, at the changes that have taken place in the last sixty years.

Gordon Clitheroe

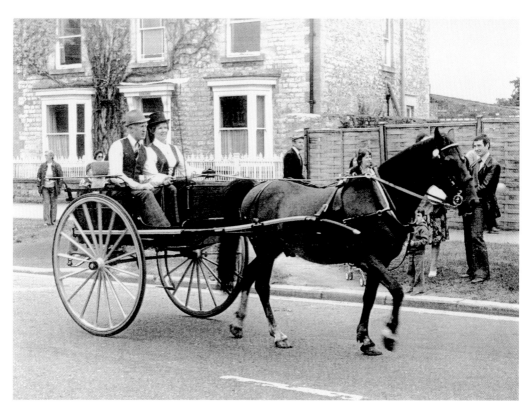

Eastgate
Bob Taylor and his wife Nancy drive their horse and trap up Eastgate. It is thought that they were taking part in one of the town's carnival parades, but the date is unknown. In the 1974 carnival there was a record turnout, which comprised of a record-breaking thirty-eight floats.

Dedication

I dedicate this book to my late wife Lynn, and brother David, who gave me all their love, support, and encouragement. Also to my family: Emma and Shane, for presenting me with two lovely grandchildren, Evie and Nancy; and my son Jonathan for sharing my love of walking. To all of my friends for giving me their time and patience, and finally to all the true inhabitants who, like me, have a love of the town.

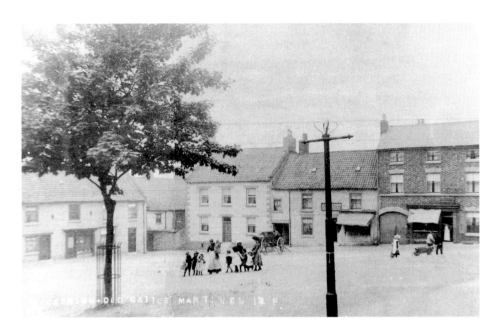

Old Cattle Market

This was later to be named Smithy Hill, and is now known as Smiddy Hill. The Lettered Board public house on the right had a butcher's shop in the room to the left of the front door, and the pub was in the room to the right. The landlord would sell meat from his horse and cart during the day and serve beer at night. The buildings on the left were cottages, and also the Yorkshire Penny Bank. The whole group of buildings on this site were demolished to make way for the new Yorkshire Bank.

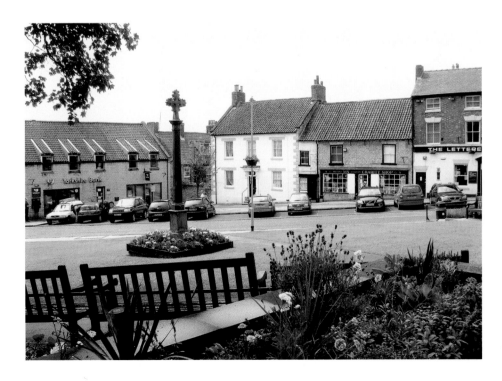

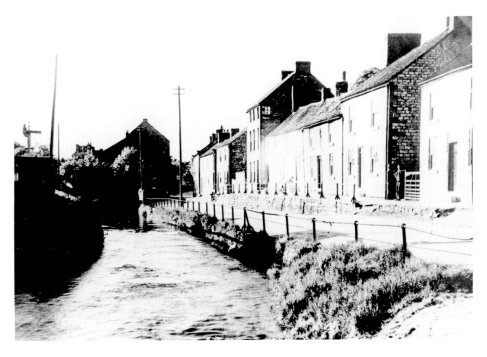

The Mill Race in Undercliffe in 1907

The High Mill was at this time owned by Sammy Baker, who also had a corn merchant's business in the Market Place. Today less water flows down the mill race, as High Mill is no longer a working mill. The name of the last miller, W. Lumley & Son, Agricultural Merchants, can be seen on the wall of the mill, above the two windows facing the town.

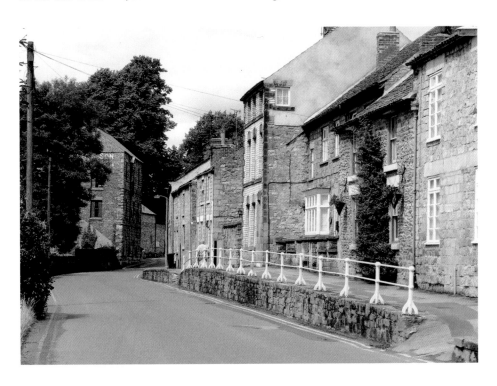

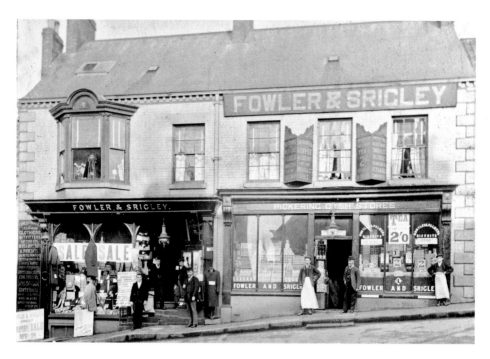

Changing Shops

Fowler and Shrigley's two shops in the Market Place. The gents' outfitter's shop on the left is having a sale, while the cash stores on the right is selling tea at two shillings, and coffee that is a luxury for the breakfast table. The shop assistants are unknown. Today the site has changed into an Italian restaurant, a travel agents, and a cycle shop, with flats above the shops. Dormer windows have been fitted into the roof, but thankfully the beautiful upstairs window on the left has been preserved.

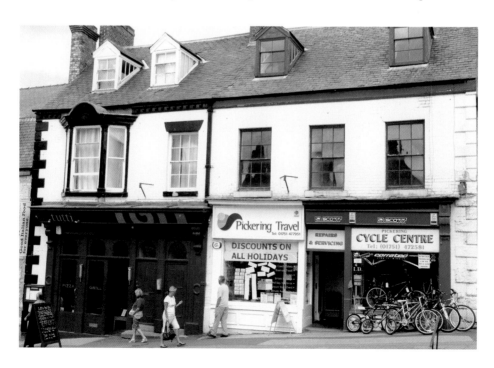

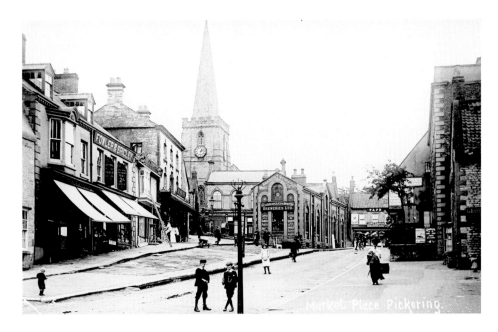

The Top of the Market Place

The building in the centre was known as the Vaults, and was at the time Scarborough and Whitby Breweries' wine and spirit store. It was first used as a bank in 1868, and was demolished ninety years later for road improvements. On the right a tree can be seen growing in front of what is now the conservative club. Today cars park on the side of the road, apart from on Mondays, which is market day, when stalls take their place.

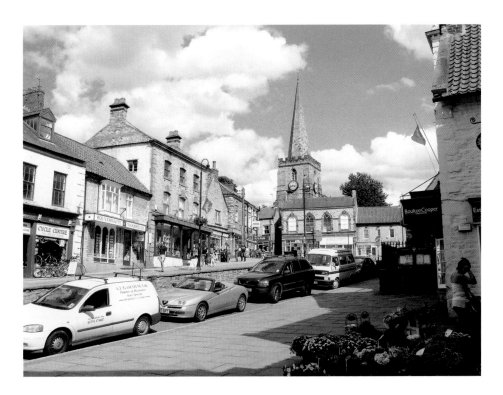

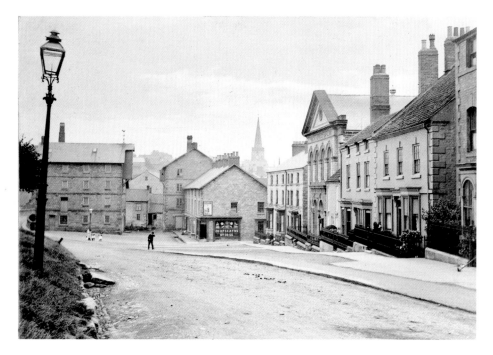

Potter Hill

This was taken before the old steam mill on the left was converted into the War Memorial Hall in 1922. The Co-operative Stores can be seen in the centre, which has also been used as Wentworth's barber shop. A second water mill can be seen behind the adjacent row of cottages, which has now been transformed and enlarged into residential flats. The memorial hall was completely refurbished in 2000, and was officially opened by the Lord Lieutenant of North Yorkshire, Lord Crathorne JP on 8 February 2001.

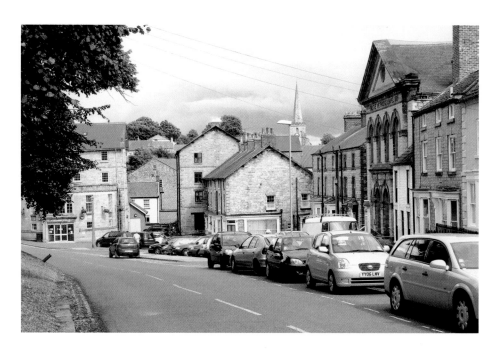

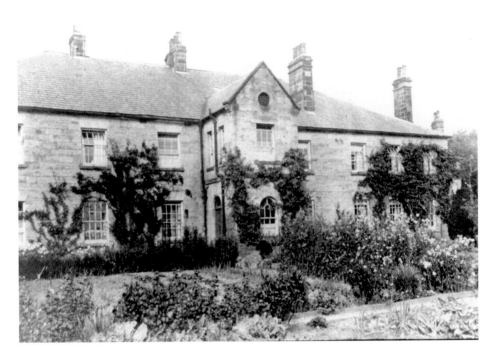

Pickering Union Work House

This was built in 1838 in Whitby Road and was demolished in 1972. Some of its later uses were as a children's home and a shelter for homeless families. After the demolition of the old building a new residential home for the elderly has been built on the site.

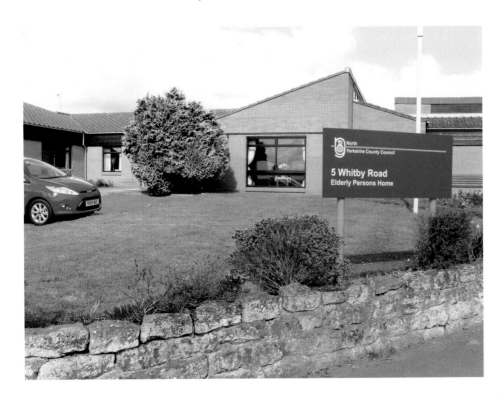

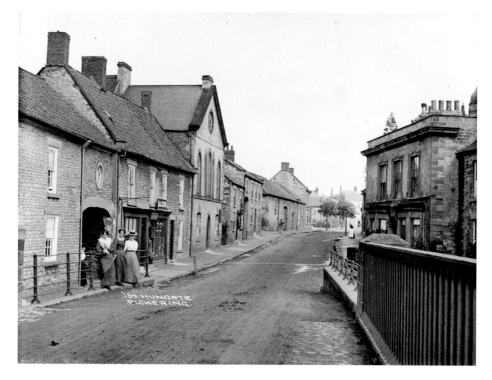

Hungate from the West

Hungate from the old road bridge over Pickering Beck in 1902. The cottages and Mason's shop behind the ladies standing on the left have since been demolished. The WRVS Centre now stands on the site, and it is also the supply entrance into the Co-operative supermarket. The old cast iron road bridge has been replaced with one built of concrete beams, and a new pedestrian bridge has been added to the southern side.

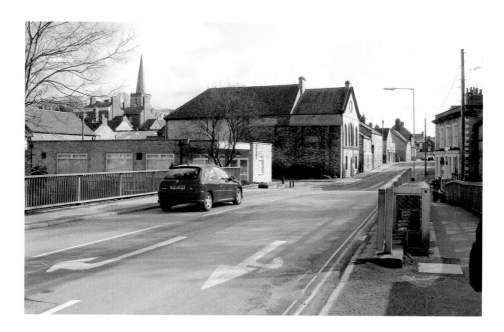

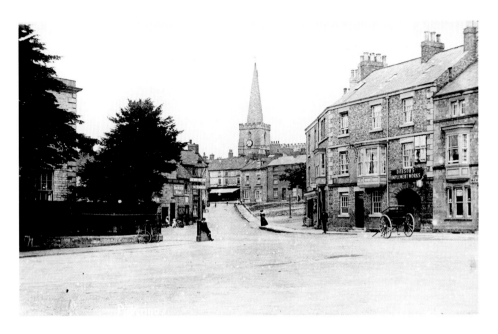

Smithy Hill

Later to be known as Smiddy Hill, this had a blacksmith's shop on the left, giving it its name. The building on the left behind the tree is the Low Hall, later to become the Forest and Vale Hotel. On the right is Dobson's Implement Works, and the Horse Shoe public house. Today the arched entrance into Dobson's Implement Works has been changed to become the front doorway of the Horse Shoe public house. The blacksmith's shop and adjacent public toilets on the left are now a butcher's shop.

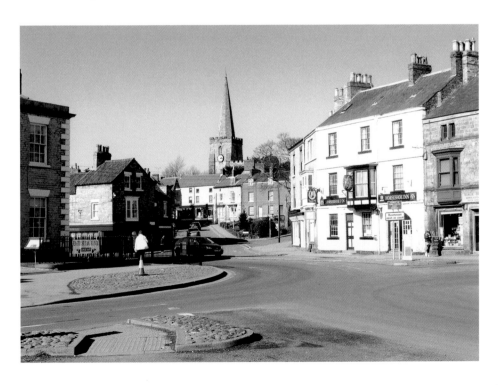

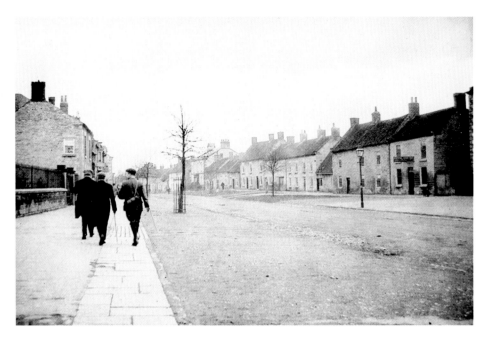

A Party of Walkers explore Eastgate in 1902

The Royal Oak public house can be seen on the right, and the steel railings on the cattle market wall are on the left. The cattle market and fire station, plus the urban district council's works depot, have gone to make way for a car park. The cottages beyond the Royal Oak public house were demolished for building the United bus station and a café. Shops and garages on the left have been replaced with the Eastgate Square development of shops, businesses, and flats. The bus station has now become a carpet and bed store.

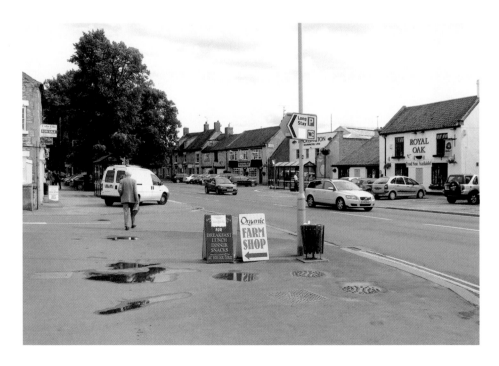

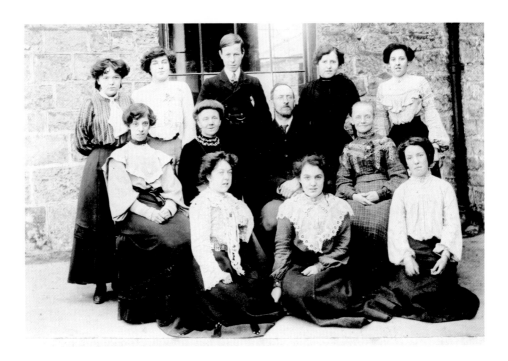

Teachers at Work

Teaching Staff of the Wesleyan School in Southgate, taken in 1903. Mr Skelton, the headmaster, is in the centre of the second row, with Margret Ann Page in the centre of the front row. The school has now been converted into the Pickering Working Men's Club, so it is impossible to recreate this group photograph. As the outside of the building is mainly unchanged, I have shown the main entrance door, where the original photograph is thought to have been taken.

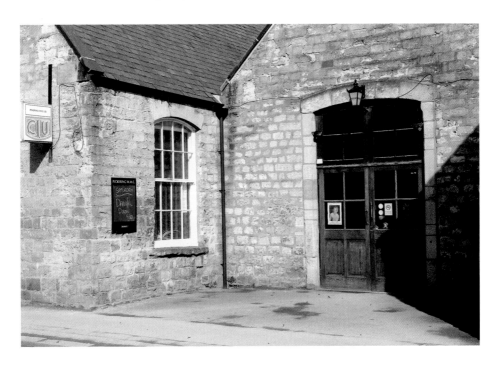

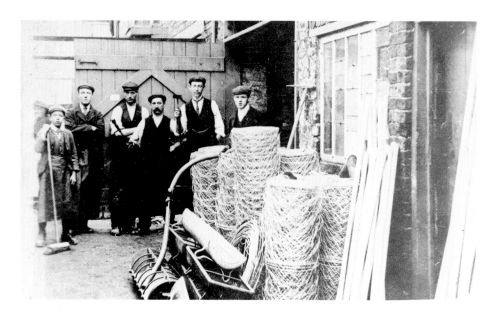

Coopers Yard, Market Place

Workmen standing outside an ironmonger's building in what was known as Coopers Yard, now changed to Champleys Yard, in the Market Place. The photograph was thought to have been taken in 1905. Mr Chandler owned the ironmonger's business until going bankrupt, when it was taken over by one of his employees, George Cooper senior. The site was also used by Mr Jack Dobson as an iron foundry in the building on the right. The whole of this lower area was demolished to make way for the towns first large supermarket, now owned by the Co-operative Group Ltd. The workmen are, left to right: ?, ?, Jack Dobson, George Penock (foundry workers) Charlie Watson, and Robert (Bob) Huby. The empty shop and the clothes shop on the right replaced Jack Dobson's foundry. The shoe shop and the adjacent supermarket replaced the ironmonger's outbuildings and storage yard.

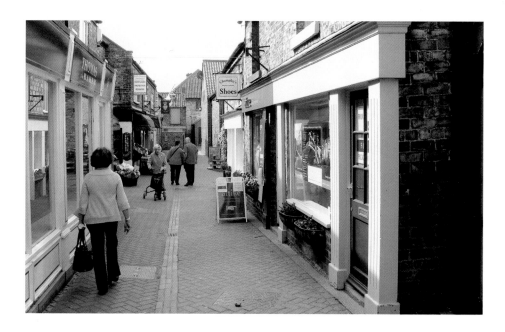

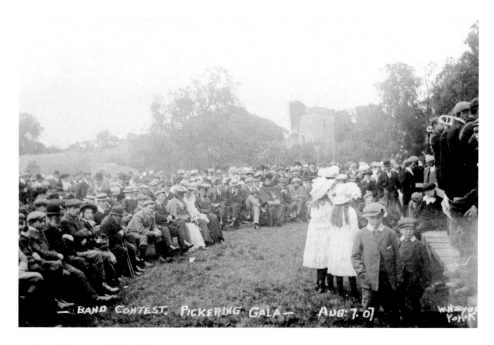

Relaxation at High Hall

This photograph is dated 7 August 1907. The annual Pickering Gala was held in the grounds of High Hall, in Castlegate, home of Major Michelson, for a number of years before the First World War. The ruins of Pickering Castle can be seen in the background. The site is now the residential housing estates Rosamund Avenue and Norman Close.

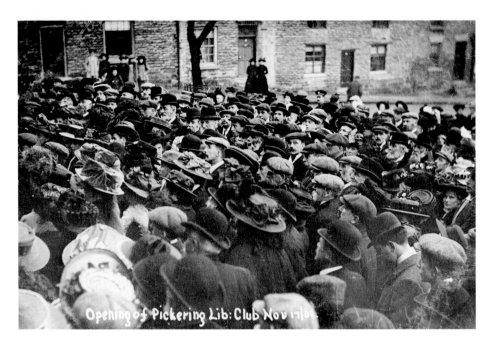

Opening of Pickering Lib: Club Nov 17/09

The Town Green

Crowds of people gather for the opening of the new Liberal club on Smiddy Hill, on the 17 November 1909, by the Right Honourable J. E. Ellis MP. The cottages behind are in Hallgarth. The grassed area with surrounding wooden benches is very popular in summer with local residents and visitors.

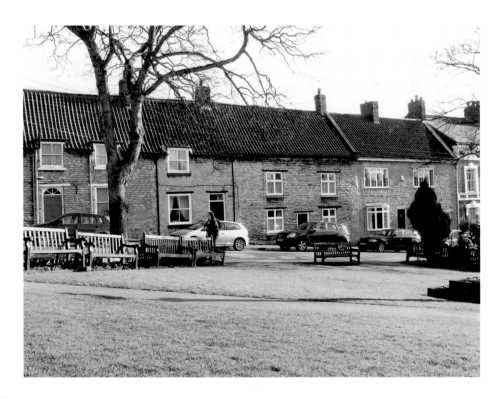

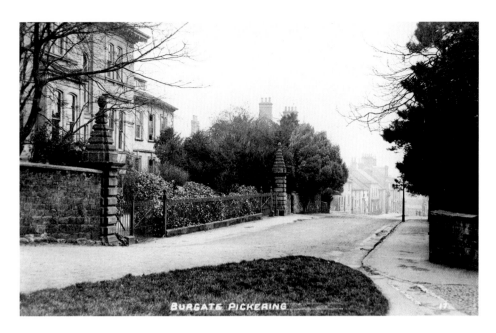

Castlegate, looking down into Burgate

The building on the left is High Hall, home of the Michelson family. It was taken over by the army when the grounds became a training camp for guards battalions after the Second World War. The house became partly derelict, and was demolished in 1963. Part of the stone pillar on the left can still be seen as a reminder of High Hall's existence. Today modern bungalows and gardens adorn the site, with a new road giving access into the new estate of Rosamund Avenue and Norman Close.

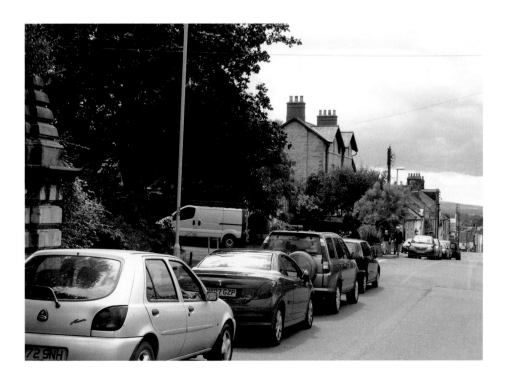

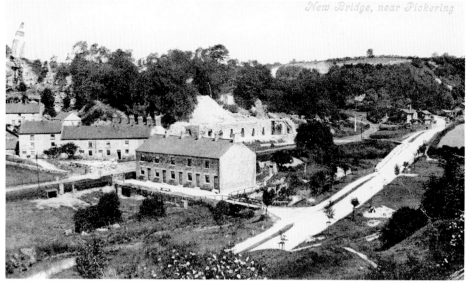

New Bridge, near Pickering

Quarry Workers' Cottages at Newbridge

This was a small community north of the town. Behind the cottages the lime kilns can be seen. These have since been demolished, along with the row of cottages. Two quarries, one on each side of the Newton Road were in use at the time. The burnt lime and limestone was removed in railway trucks using the Pickering to Whitby railway line, which can be seen behind the row of cottages in the foreground. The date was March 1907. The railway line closed in 1965, and was reopened in 1967 as the North Yorkshire Moors Railway.

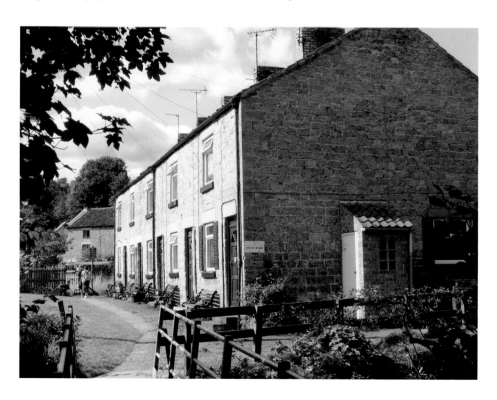

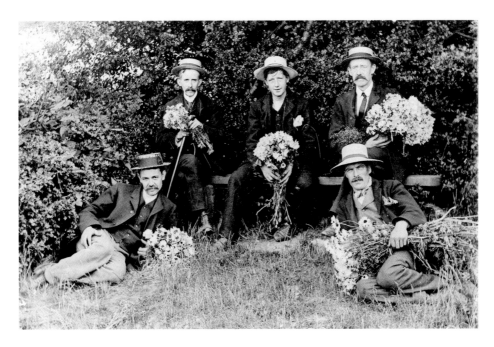

Rest Day

The men posing with bunches of wild flowers all worked in the limestone quarries at Newbridge, near Pickering. The date was around 1900, but the event was not recorded. They are, left to right: John Smith, John Wilson, Albert Snowdon, John Snowdon, Charles Nicholson. As the location is not recorded, I have shown the old bridge and railway crossing at Newbridge. The water pump that supplied these cottages can still be seen at Beck Isle Museum in Pickering.

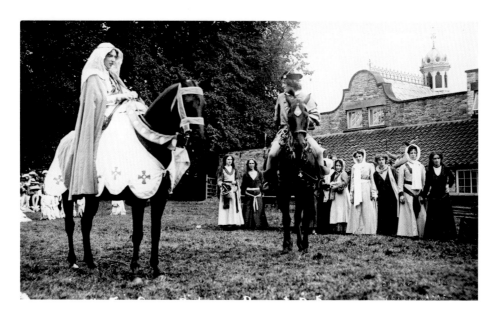

A Community Event

In August 1910 the Pickering Pageant was held in the castle, and here we see some of the town's inhabitants who took part in the event. They are in the grounds of High Hall, which was next to the castle, and the elaborate roof of the hall's outbuildings can be seen on the right. The pageant was hailed as a great success, and extra train excursions brought many spectators into the town. The admission price was 1s 6d. and the sale of tickets produced an income of £824. New houses now occupy the site, and the ornate outbuildings have been replaced with the Ministry of Agriculture offices on the left, which opened in 1964 and are now in private ownership, and the telephone exchange on the right.

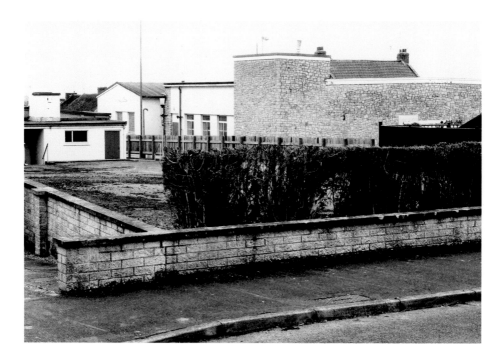

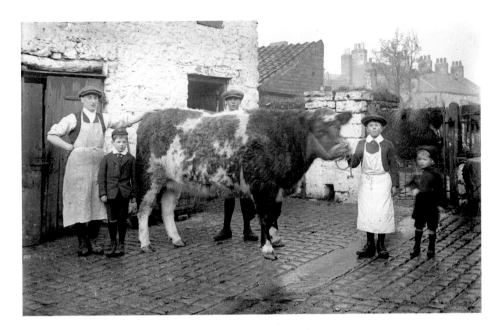

Barber's Slaughterman

This is the slaughterhouse behind George Barber's butchers shop in the Market Place. The young man standing behind the animal is thought to be Roger Fletcher. Barber's butchers shop carried the royal coat of arms above the front door, to indicate that they had at one time supplied meat to the royal family. Today the slaughterhouse has been turned into private garages, and the butcher's shop was turned into a grocer's shop, and is now a café and baker's shop.

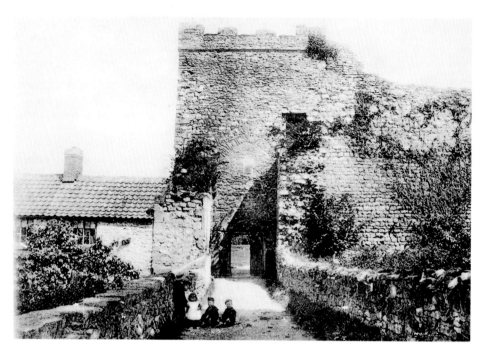

The Entrance to Pickering Castle
The cottage on the left was occupied by the castle custodian, who like the his father who did the same job before him, was called Bob Sheffield. The Sheffield family moved out in 1953 and the house was demolished soon after.

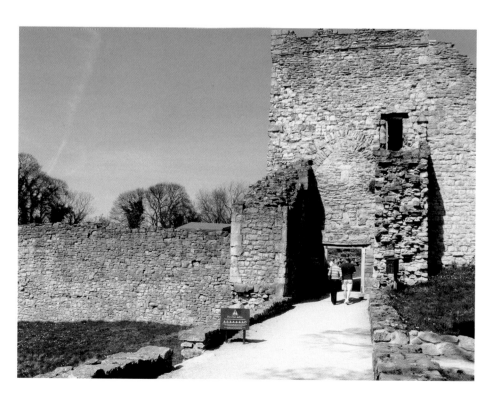

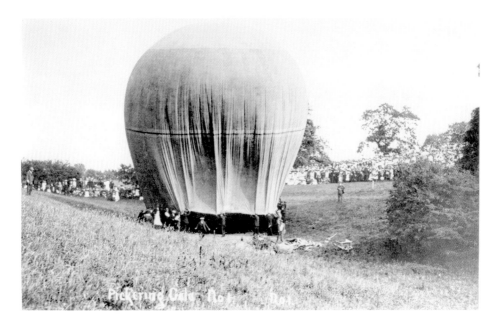

The Balloon Goes Up

The Pickering Gala was held in the grounds of High Hall in Castlegate, in what was known as the Avenue Field, next to Pickering Castle. On Wednesday 26 July 1911, Dolly Shepherd the famous balloonist appeared at the event. She moved around the country transporting her balloon with a wagon pulled by four horses. The photograph shows her balloon being inflated by lighting a bonfire close to it. Once inflated, it would rise with Dolly hanging onto a trapeze below it. When it was high enough, she would pull a ripcord in order to make the balloon collapse. She would then open a parachute and float back down to the ground. It is difficult to pinpoint the exact place that the balloon flight took place, as most of the site has had housing built upon it, but this is a small part of the original site that is still intact.

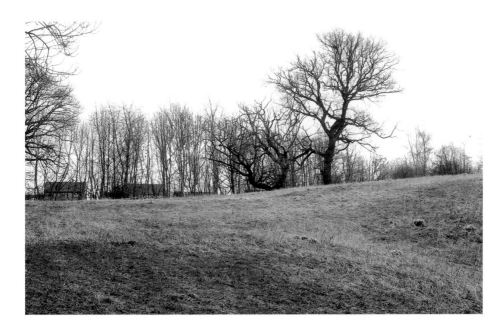

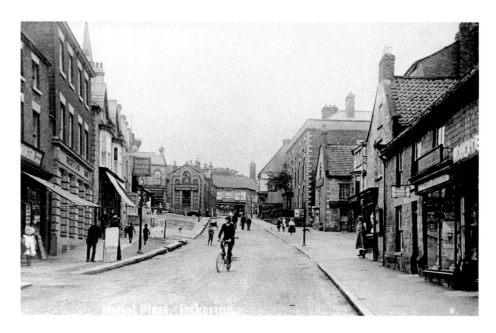

The Market Place

Becketts & Co. Bank is on the left and the Vaults, owned by the Scarborough and Whitby Brewery, are on the left of the road. They were built as a bank in 1868 and demolished 1958 for road improvements. On the right is the conservative club, and the George Hotel is behind the girls on the right. Today the Market Place is in constant use by motor vehicles parking on the road, and most of the shops have changed their use, for example the butcher's on the right is now a charity shop.

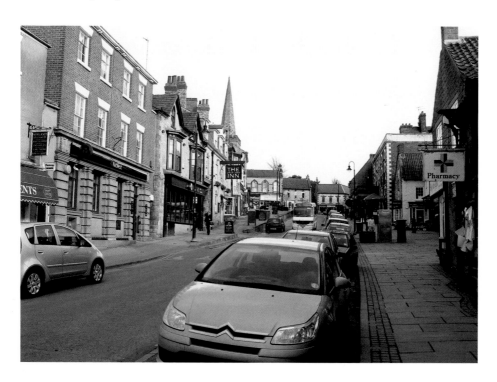

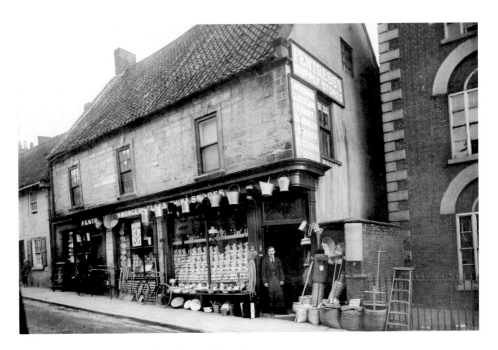

Fentress's Supply Stores in the Market Place

They sold everything from china and ironmongery to groceries. The man standing in the doorway is John Arthur Sawdon (born 1871 and died 1957, aged 86) who worked in the store. The building on the right was once the home of whaling captain Nicholas Piper, who owned two whaling ships sailing out of Whitby. This large mansion was later turned into Barclays Bank and the conservative club. The shop has been turned into a fruit and vegetable shop, and on the right the extension of Barclays Bank can be seen.

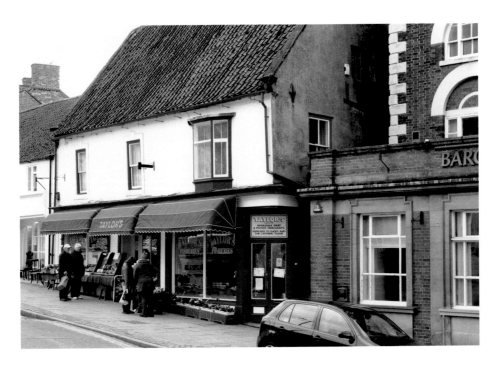

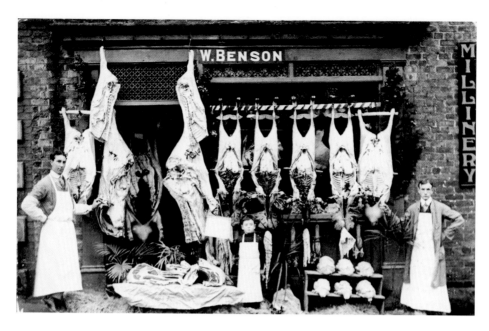

Butcher's Shop

W. Benson's butcher's shop on Potter Hill. Animal carcasses and game hang outside the shop, as was the custom at the time. The shop later became a fish and chip shop. It is thought that at one time the property was owned by the Duchy of Lancaster.

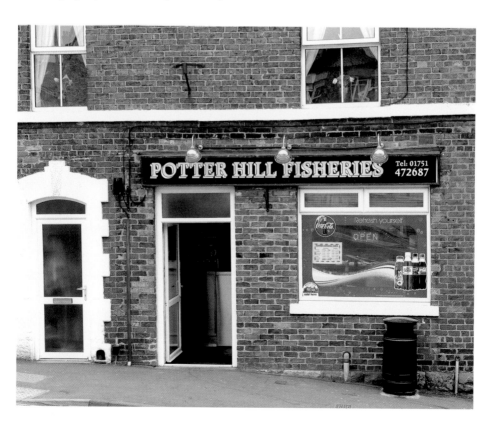

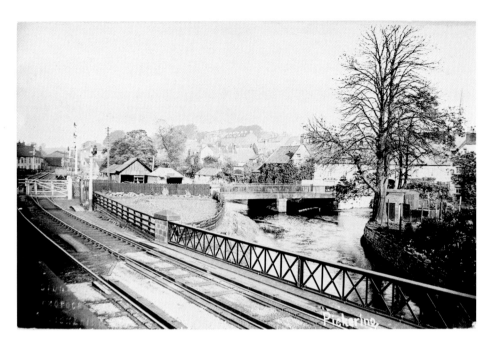

Hungate Railway Crossing in 1910

The railway track crosses the main road, the goods yard, and enters the station on the left. The shops and cottages on the right of Pickering Beck were later to be demolished to make way for the WRVS Centre and Presto Supermarket, (now the Co-operative Store). The building behind the hedge in the centre was replaced with a fish and chip shop, and the road bridge over the stream was also replaced. A cycle shop was built in the triangle of land in the centre and has also been demolished.

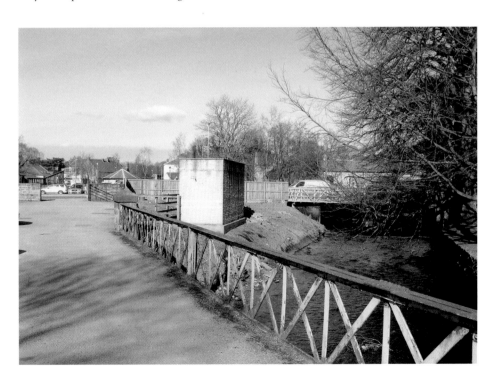

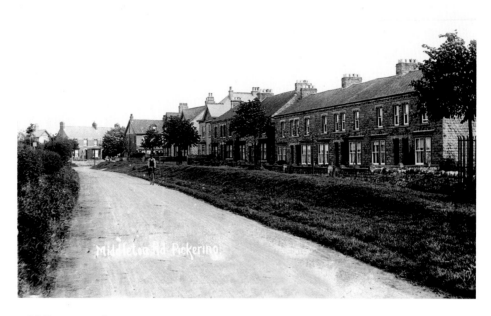

Middleton Road

A cyclist rides down an unsurfaced Middleton Road. The row of houses on the right is called Franchise Terrace, built by a local builder, the father of the famous Pickering photographer Sydney Smith. The Smith family moved into no. 1 when the row was completed. The increased use of Middleton Road by vehicles and children attending the schools has seen both road improvements and traffic calming humps installed.

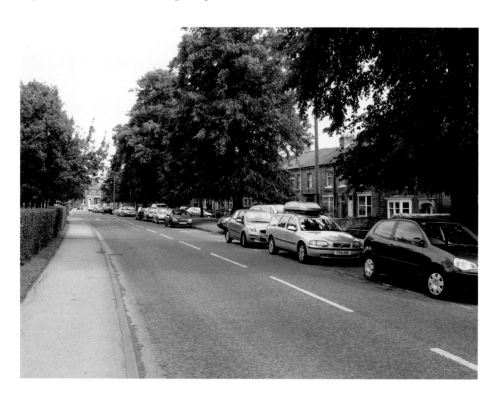

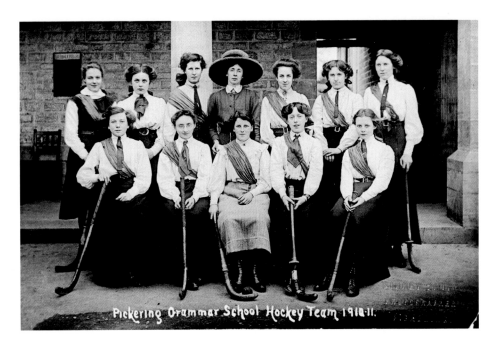

Pickering Grammar School Hockey Team 1910-11.

The Grammar School

The grammar school hockey team pose outside the school on Middleton Road in 1910-11. Lady Lumley's Grammar School was opened in 1904, by the Right Honourable A. H. D. Acland, and had thirty-six pupils. The headmaster was Mr E. G. Highfield, who was to serve until his retirement in 1930. Since the opening of a new grammar school in Swainsea Lane, this school is now used for junior school children.

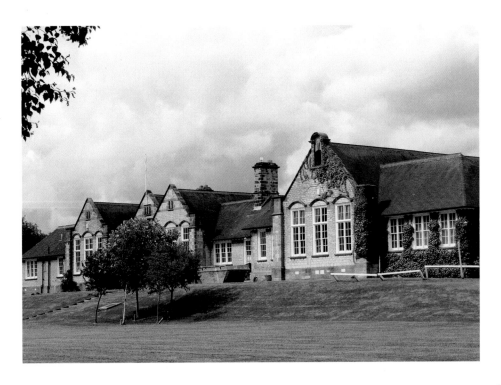

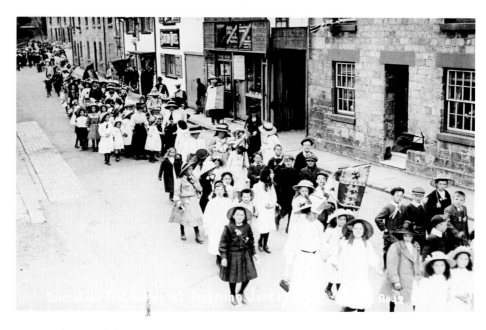

Coronation Festivities in Park Street on 22 June 1911

Schoolchildren parade past the Station Hotel, and the small wooden shop that became Sydney Smith's Garage. The garage has since been demolished, after being taken over by Smith's brother-in-law Tommy Thompson, and is now the access to the Station Hotel car park.

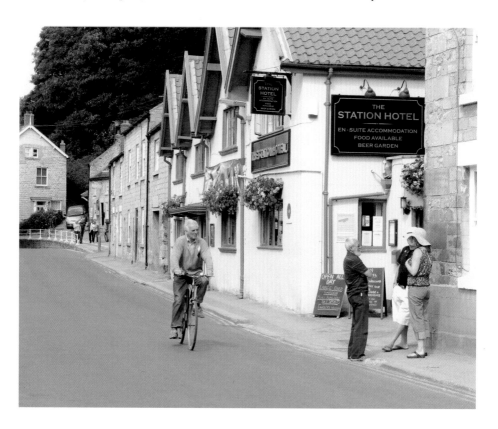

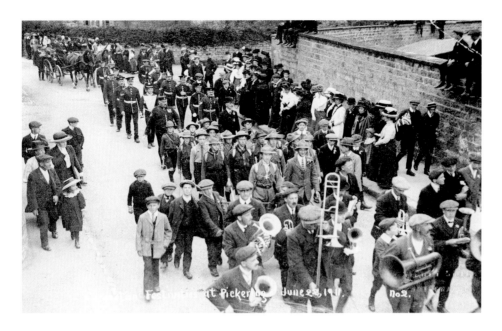

Coronation Parade on 22 June 1911

The band, followed by the boy scouts, pass Train Lane, with the railway goods yard wall on the right. They are walking from Southgate into Hungate. The site today is adorned with the town's only set of traffic lights. On the right Ropery Road has replaced the railway track and signal box, and the railway goods yard is now the Ropery car park.

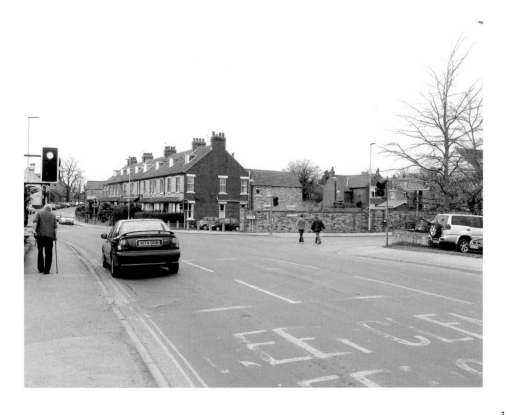

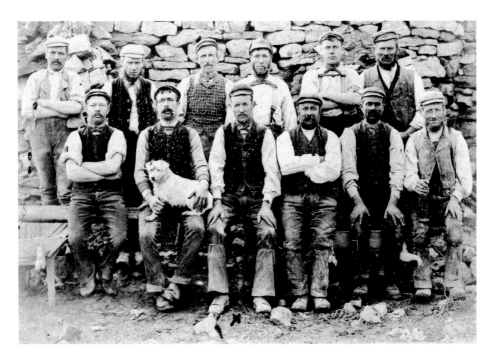

Quarry Workers at Pickering

The date of this photo is unknown. The workman third from the left on the front row is William Linton. The photograph would have been taken at Newbridge quarries north of the town. One of them has been used as the town's rubbish tip, and is now full and closed, but this one is still producing limestone. There was also a sandstone quarry above this one, where the stone was carried down on a small railway track to a crushing plant here. It also closed down in the 1960s. This is how the quarry looks today.

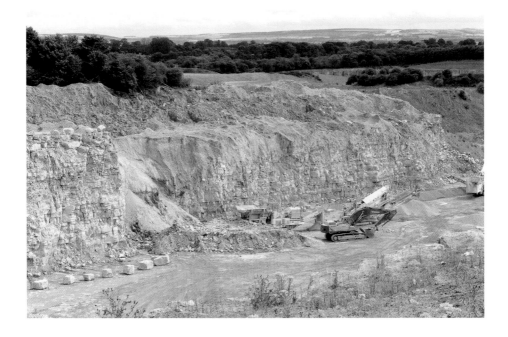

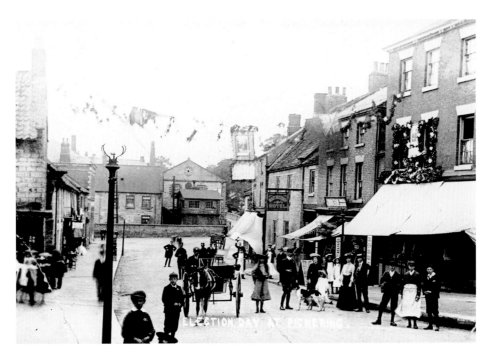

Election Day in the Market Place

Flags and bunting fly across the street and flowers adorn the portraits of possibly local councillors. The date is unknown. Becketts Bank is on the right, and seems to be canvassing for one of the family. The railway line behind the wall in the centre, along with the signal box, has now gone.

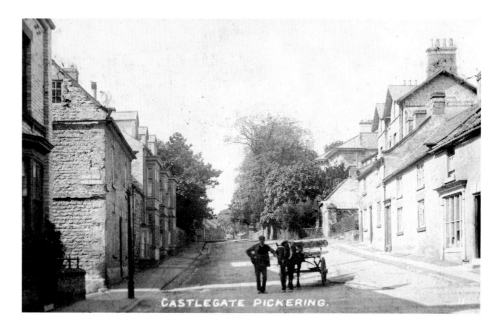

CASTLEGATE PICKERING.

Castlegate

A view of Castlegate taken in 1910, showing a man with his horse and flat cart. On the left is the top of Brant Hill, with a sign pointing to the railway station. Behind the trees on right is High Hall, home of the Mitchelson family. The only major change has been the demolition of High Hall in 1963, to be replaced with new dwellings.

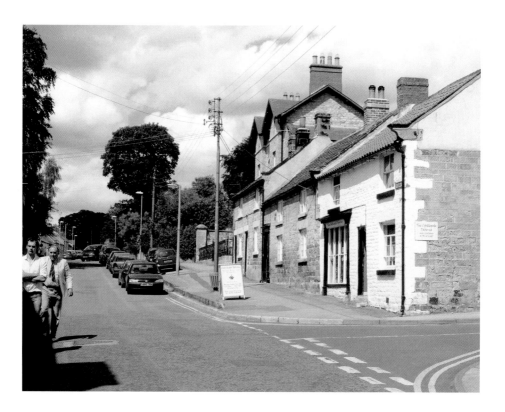

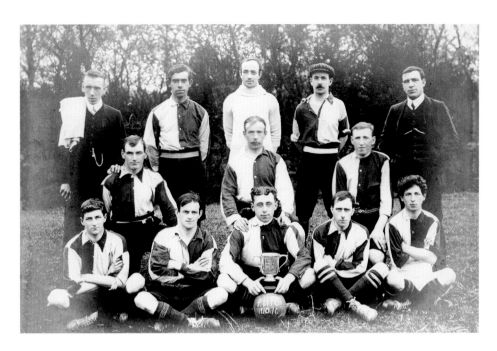

Sport

Pickering Hotspur Football Club in 1910-11. They were Beckett Minor League champions in 1908-09, 1909-10, 1910-11. The team are, back row, left to right: M. Fletcher, H. Stainsby, F. Blakelock, R. Blakelock, E. Hardy. Middle row: J. R. Stockdale, H. P. Pool, R. Marshall. Front row, left to right: R. W. Pickering, J. Nicholson, A. F. (Codge) Frank, (holding the cup) T. Walker, H. Nellis. Their football field at this time was in Goslipgate. Pickering Town football club now play on the recreation field, which is shared by the cricket and bowling clubs. Today we see a cricket match.

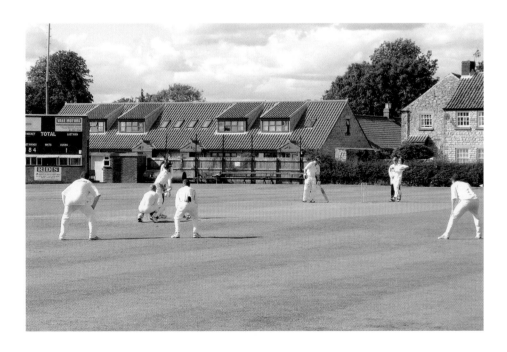

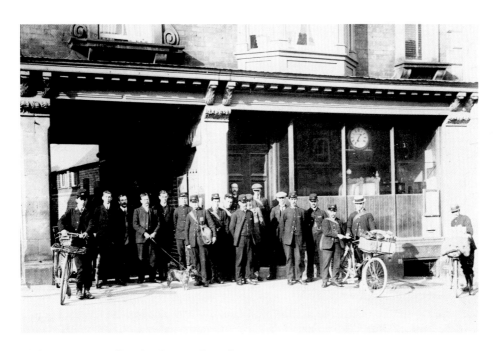

Pickering Post Office in the Market Place

Postmen and office staff pose outside. Through the archway the sorting office can also be seen, while the indoor market became Holiday's Garage, and was later used for the post office delivery vans. The rooms above the post office were used to house the town's first telephone exchange. Down the yard on the left Henry Coverdale employed eight cobblers to make and repair boots and shoes for sale in his shoe shop in the Market Place, now a wine bar. The post office is now a branch of Boots the Chemists.

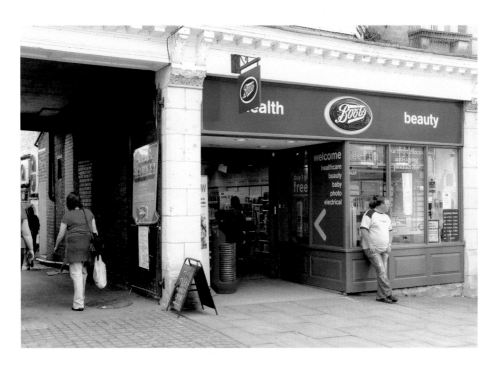

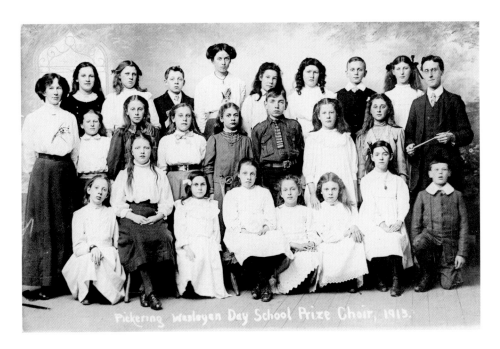

Pickering Wesleyan Day School Prize Choir, 1913.

The Wesleyan School Choir

Teachers and pupils from the Wesleyan day school prize choir pose for the camera in 1913. The school has now become the third home in the town for the working men's club.

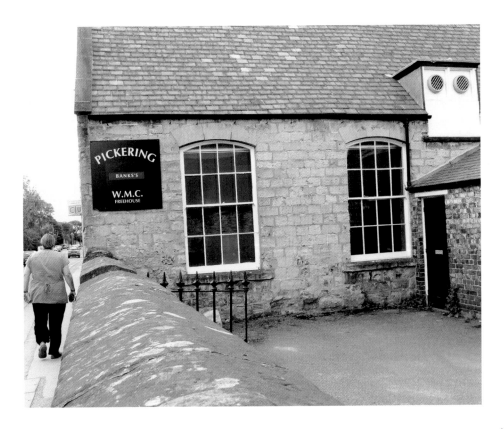

PICKERING
BANKS'S
W.M.C.
FREEHOUSE

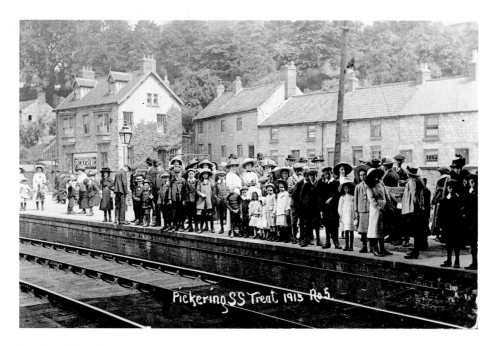

Pickering SS Treat 1913 R.S.

Sunday School Treat

Parents and children dressed in their Sunday best await the train to take them to Scarborough for the annual Sunday School treat in 1913. They are on the north end of Pickering Station, with Castle Road between the houses in the background. Today the North Yorkshire Moors Railway has added a bridge to give access over the rail track.

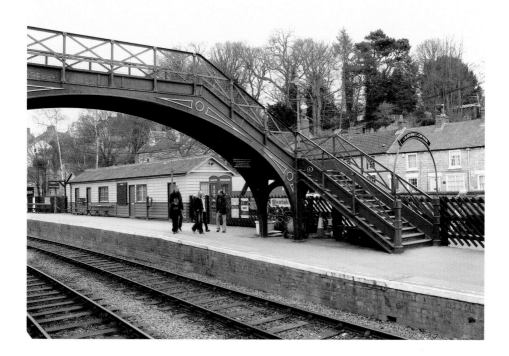

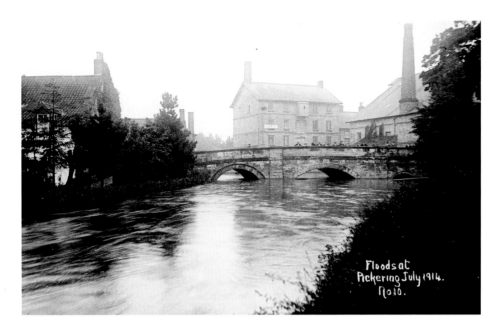

Floods at Pickering July 1914.
Nold.

Floods at Beck Isle

The floods of July 1914, taken at Beck Isle. Behind Pickering Bridge, two mills can be seen. The one on the left has since been converted into flats, while the one on the right was turned into the War Memorial Hall in 1922. It also housed the town's first swimming pool and public baths. In the year 2000, the hall was transformed into the modern community centre it is today. HRH Prince Charles paid a visit to see the work being carried out in 1999.

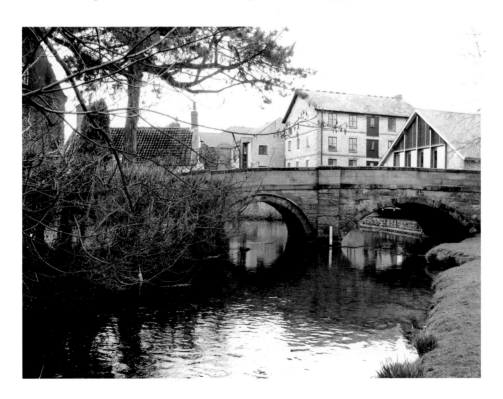

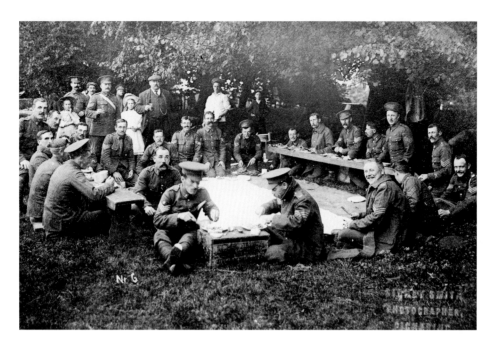

The Calm before the Storm

Territorial soldiers enjoy a meal in the grounds of High Hall, near Pickering Castle in 1914. Soon they would march down to the railway station, to embark on their journey to the War in France, where sadly seventy-four of the local men would be killed. All that remains of High Hall and its grounds today is one large stone pillar to the left of this bungalow.

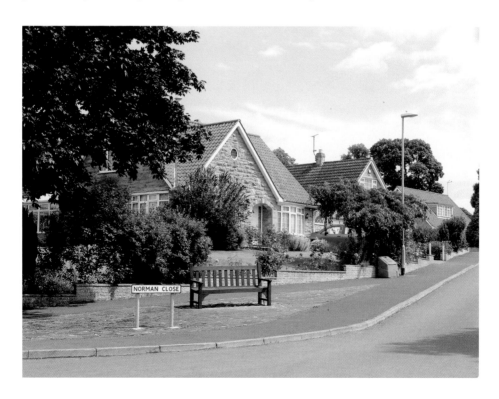

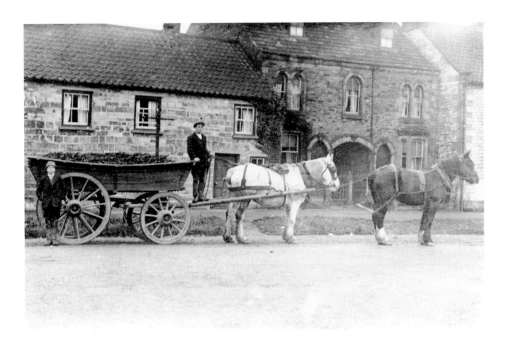

Westgate

Two horses are yoked up to pull this wagon, thought to be loaded with coal, in Westgate, near the junction with Potter Hill. Little has changed apart from the mode of transport.

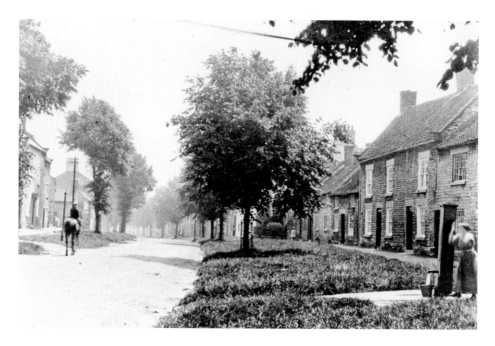

Eastgate

A lady draws water from one of the town's pumps in Eastgate, while the only traffic is a man riding his horse down the road towards Thornton-le-Dale. Today the pump has gone, while dormer windows and the motor car have arrived.

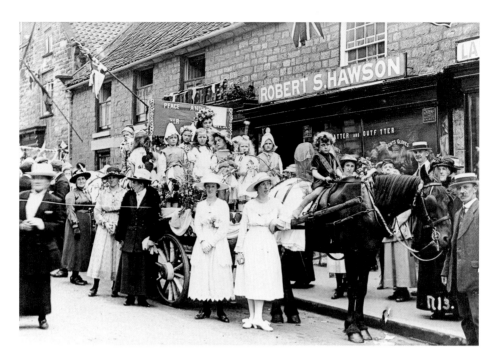

Peace Day in Pickering, in 1919

The procession in the Market Place was to celebrate the end of the First World War. The children are sitting on an horse-drawn rulley. The steel grill in the shop window of the electrical retailer on the right is a sign of the times we are living in.

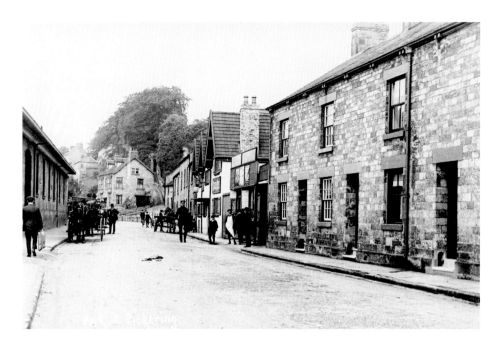

The Railway Station

Horses and small conveyances line up outside the railway station on the left to pick up railway passengers and transport them to the Black Swan and White Swan hotels. A policeman walks past the Station Hotel in Park Street. Today we see how busy Undercliffe has become.

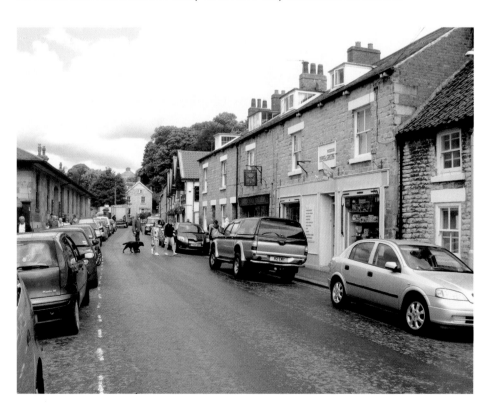

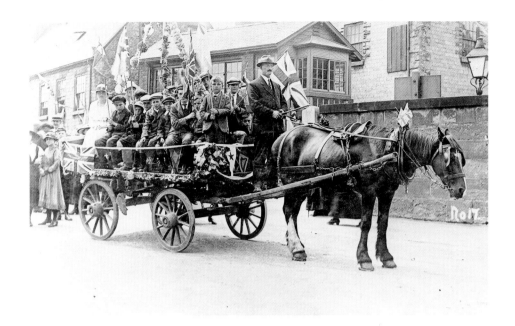

Bridge Street Crossing

A decorated horse and rulley rests near the railway crossing at the bottom of the Market Place. The signal box that controlled the crossing gates into Bridge Street can be seen behind the people. It is not known if the occasion was the coronation in 1911, or the Peace Day Parade to celebrate the end of the First World War in 1919. Now the signal box has gone, along with the level crossing, and the railway track into the goods yard has been replaced by Ropery Road and café customers.

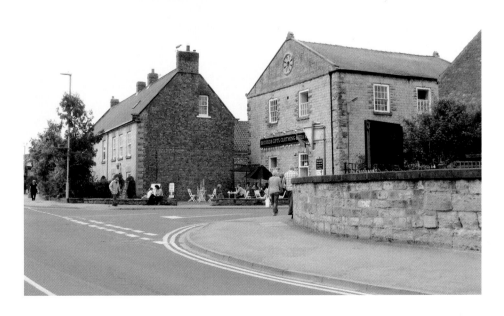

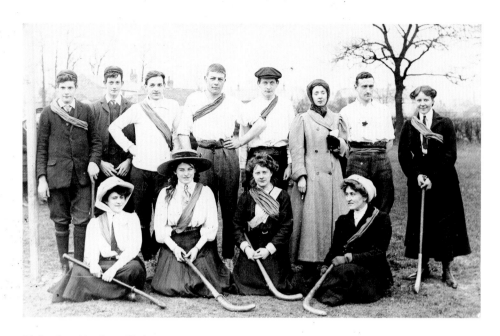

Pickering Hockey Club

The date of this photo is unknown. The members used to play on a ground in Goslipgate, near the junction with Vivis Lane. The town's first council housing estate was built here, and opened by Lord Howard on the 12 April 1933. The old timber yard behind this area has been replaced with the new housing estate of Kingfisher Drive. It was also the site of an old army camp that was later used to house families until they moved into council houses, and was known locally as 'The Squatters'.

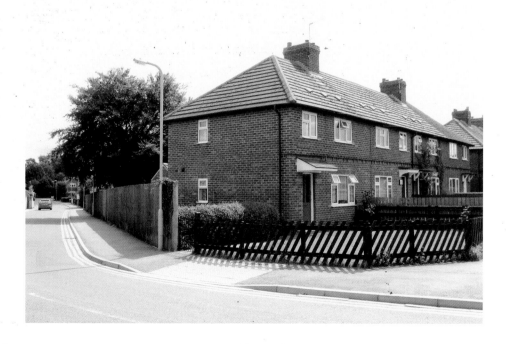

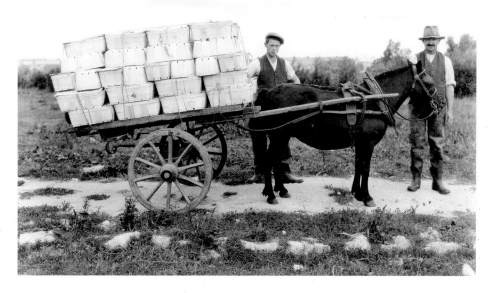

Pickering Water Cress Beds

A small horse called 'Peggy' pulls a flat cart loaded with boxes packed with water cress, at the cress beds in Westgate Carr Lane. The man holding the horse is Jack Harper. The boxes were delivered to the railway station, and sent to hotels all over the country. Daffodils were also grown around the ponds as a crop. They were cut and sold, also using the railway network. At the present time some of the ponds are used for raising trout to supply restaurants. Water wheels are used in the ponds to add oxygen, in order to keep the fish alive in hot weather, and nets are stretched over the ponds to protect the fish from predators like herons.

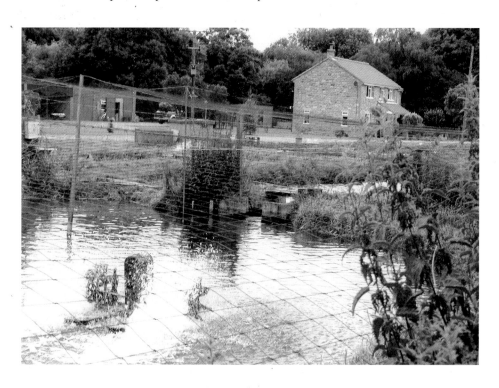

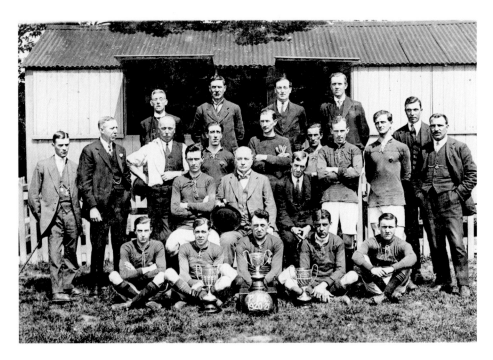

Pickering Football Club

Players and officials pose in front of the pavilion with the three cups that they have won in the 1920-21 season. Today the club play on the recreation ground.

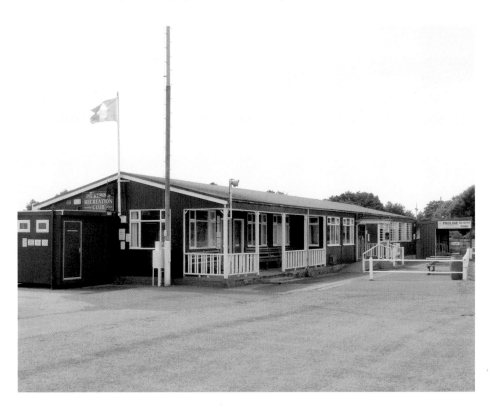

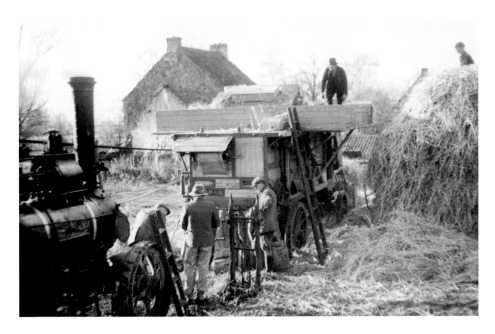

Threshing Day

This is thought to have been taking place at Mr Coultman's farm, Keld Head. The threshing set, comprising of a traction engine and threshing machine, were usually hired in from Stephenson's of Cropton. Today an extension has been built onto the cottage behind the threshing machine, and two new houses have been built in the stack yard.

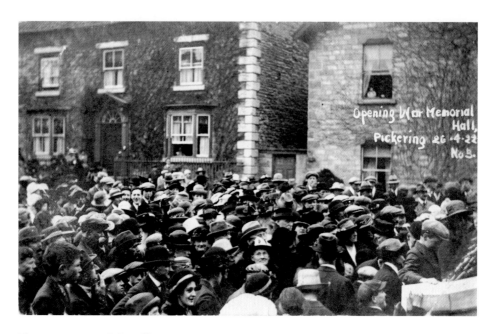

The War Memorial Hall

The opening of the War Memorial Hall on Potter Hill, on 26 April 1922. The hall was created from an old steam-driven corn mill, bought by public subscription. Ten days before the official opening, General Sir Ivor Maxse, head of the British Legion, unveiled the memorial tablets, recording the names of those people from the town and district who gave their lives for their country during the First World War. The names were restored when the tablets were refitted into the refurbished memorial hall in 2001.

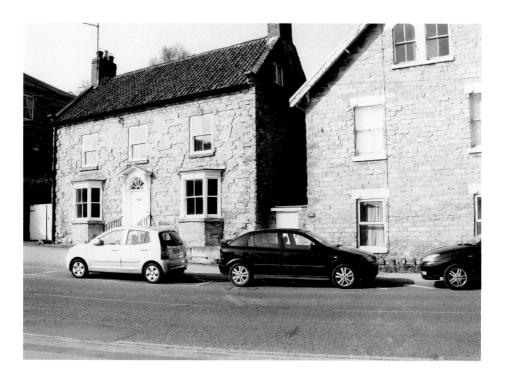

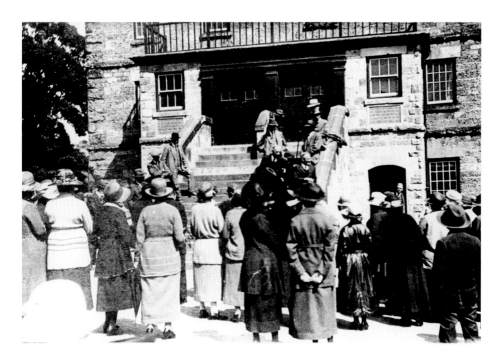

Swimming Baths

The opening of the town's first swimming baths, inside the memorial hall on 30 June 1924. Demolition of the same disused swimming baths took place in October 2000, as part of the hall's refurbishment.

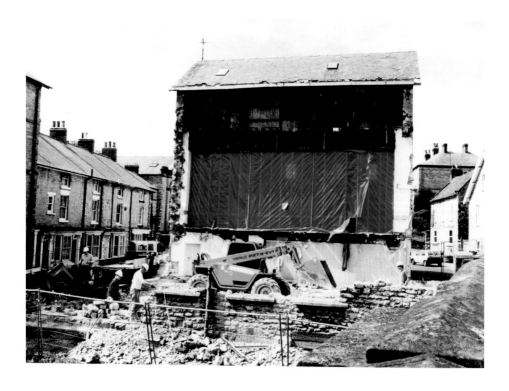

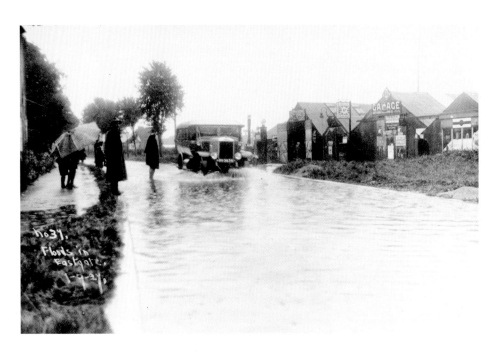

Floods in Eastgate on 7 September 1927

The garage on the right was known as 'the Green Garage'. It was owned by Major Jack Elwis, then later by Mr Fred Ford, and was always painted green. It was demolished to make way for the much larger North Riding Garage, which has recently closed, and is expected to be replaced with a new development.

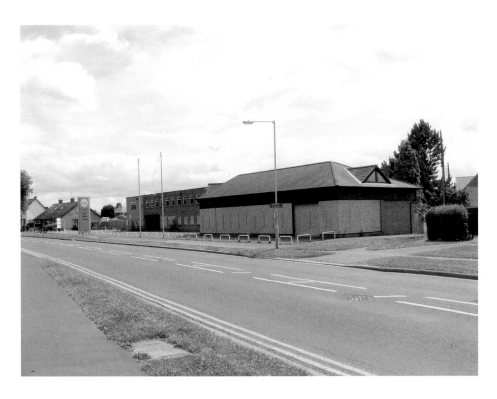

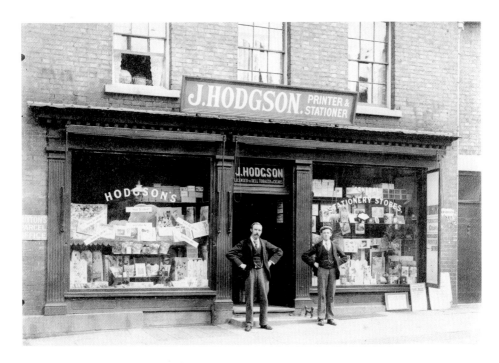

J. Hodgson, Printer and Stationer

The shop is next to the Bay Horse public house in the Market Place. The printing works occupied a building behind the shop, and was last owned and used by Eric Dewing. Following its closure, the Columbian printing press and other printing equipment moved to the town's Beck Isle Museum, were it is still in use. Today the shop houses a newsagents and a post office.

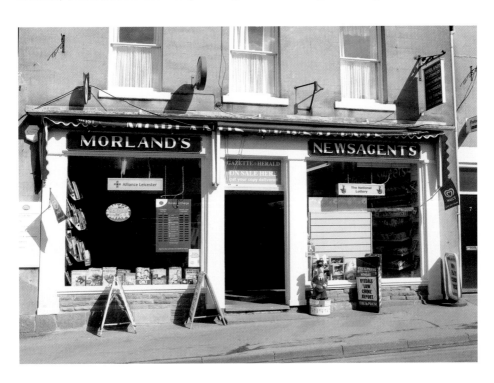

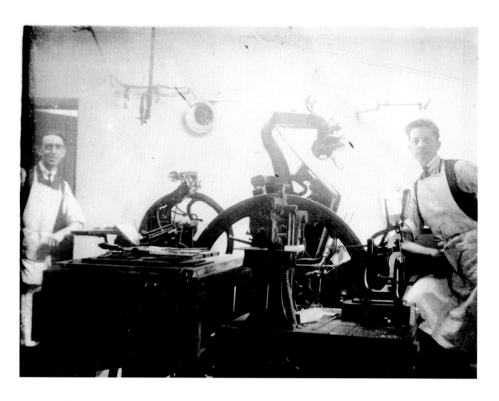

The Printing Works

Inside the printing works behind Hodgson's shop, Market Place. From 1922 to 1936 the printing works belonged to Mr A. J. Hunnam. The man on the left is Mr Black, who worked for Mr Hunnam, and later took over the business. On the right is Eric Dewing who became the owner after Mr Black. Eric Dewing closed the business after crushing his hand while using a small treadle printing press inside his works. Eric Dewing's notice board and the magnificent Columbian printing press can be seen as you enter the printing room at the museum.

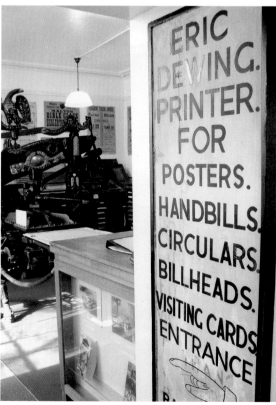

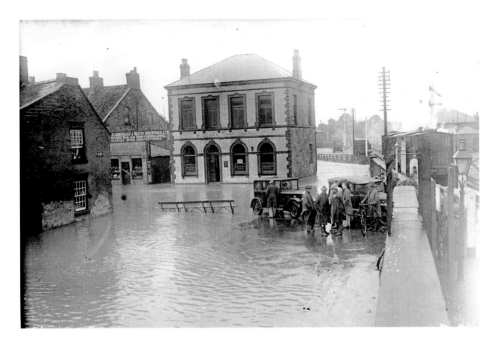

The Market Place Floods

Floods at the bottom of the Market Place on 23 July 1930. Wooden benches have been moved into the water in order to create a footway above the flood water. The train has just moved over the Bridge Street level crossing into the goods yard on the right. The Midland Bank Ltd is in the centre, and adjoining it on the left is the Scarborough and Whitby Breweries off-license. Today a sandwich shop has replaced the off-licence, and the building on the right, built on the goods yard site, are public toilets.

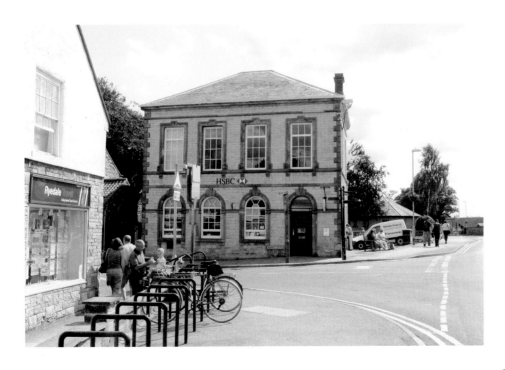

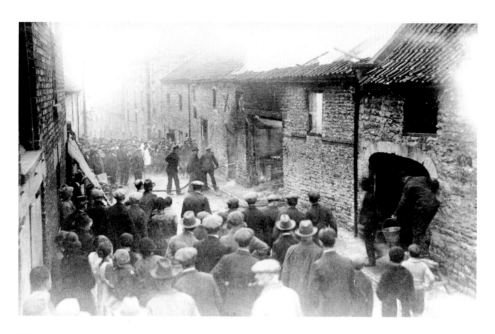

Pickering Fire Brigade

Fire at Charlie Bolton's workshop in Willowgate in November 1930. Mr Boulton was repairing his car inside the garage and joiner's shop, when the car caught fire and the petrol tank exploded, which destroyed the car and all the shop contents. Mr Boulton suffered severe burns but recovered. The fireman holding the fire hose is Joe Taylor. Very little has changed, but the large building in the centre is the back of the now closed Castle cinema, which is soon to be replaced with new dwellings.

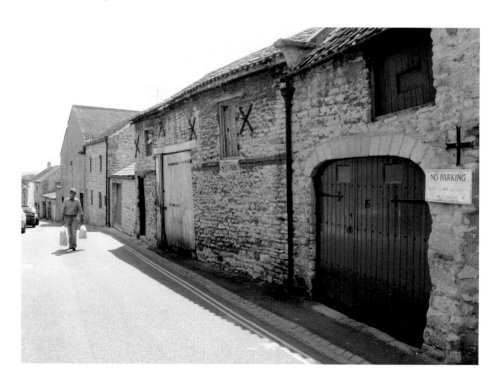

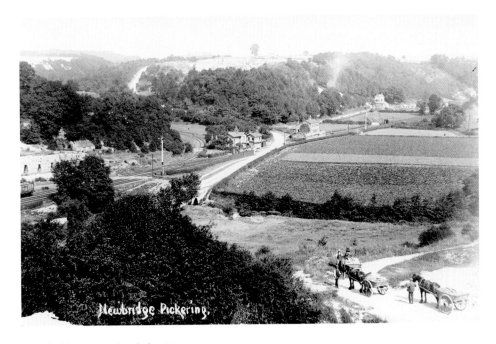

Newbridge Pickering.

Newbridge, North of the Town

This photograph shows both quarries in operation. Railway lines can be seen leaving on the Pickering to Whitby line, heading into the quarries for the removal of lime and limestone. Smoke is rising from the quarry on the right. Due to tree growth it is impossible to show the same view, but most of the quarry workings have now gone. However, the limestone-burning kilns in Newbridge Road can still be seen.

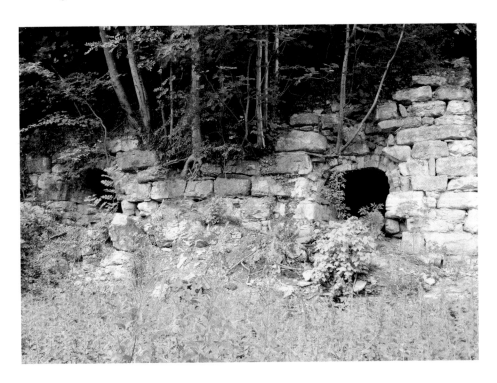

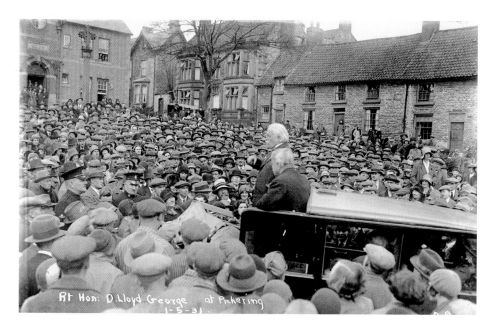

Rt Hon. D. Lloyd George at Pickering
1-5-31

Political Rally

The Right Honourable David Lloyd George speaks to a large crowd of people on Smiddy Hill on 1 May 1931. The Liberal club is on the left and the cottages in Hallgarth are on the right. The large house behind the tree is One Oak, which served as a Red Cross hospital for wounded soldiers during the First World War. Little has changed apart from the gardens and bench seating that has been provided, and today people enjoy the music being played to them by Stape Silver Band, which celebrates its 125th anniversary in 2009.

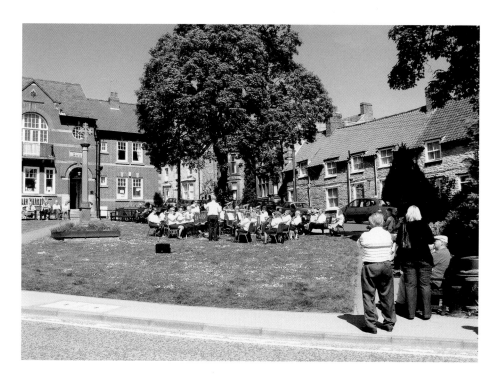

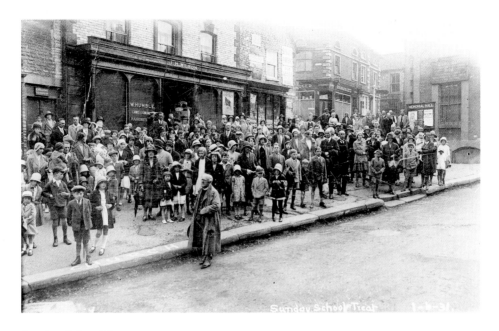

Sunday School Treat

This crowd of children, parents and well-wishers at the top of the Market Place are thought to be leaving the parish church on the way down to the railway station in Park Street to start their Sunday School treat train journey to Scarborough, on 1 June 1931. Today the Vaults building has gone and the footpath raised as part of the road improvements undertaken in 1958. The flag flies for Yorkshire Day, 1 August.

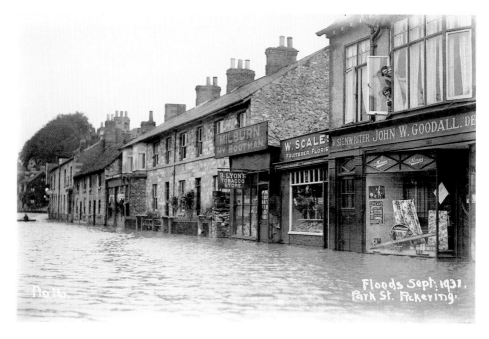

Floods hit the Town

Flooded Park Street, in 1931. On the left 'Eddie' Smith, son of the photographer Sydney Smith, rows his boat up the road. The Goodall family look out of the bedroom window above the shop on the right. B. Lyons' tobacco store and W. Scales' shop have now gone and, along with John W. Goodall's, has been changed into the Cantonese restaurant. The town is still living with its constant flooding problem, as this street was flooded again in June 2007, and still awaits protection from future floods.

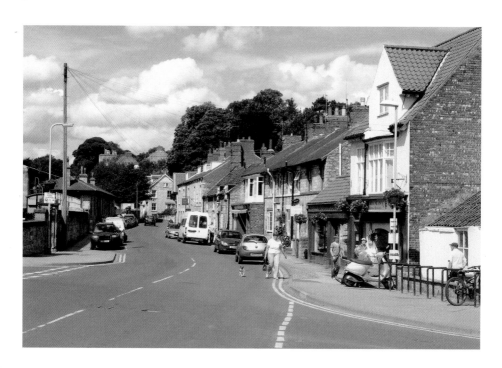

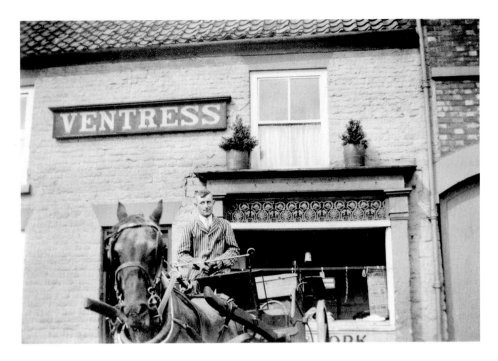

Ventress Butcher's

Frank Bointon leaves Ventress butcher's on Smiddy Hill, driving his horse and trap. Frank worked as a butcher and would sell meat from the back of his cart. The archway on the right was part of the Lettered Board public house, and landlord Bob Arundale also sold meat by day from his flat cart, and beer by night. Today Ventress butcher's shop has changed into a charity shop.

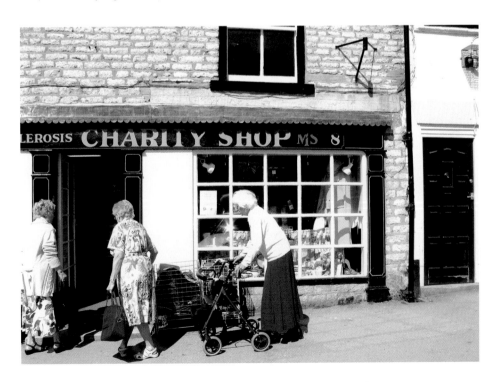

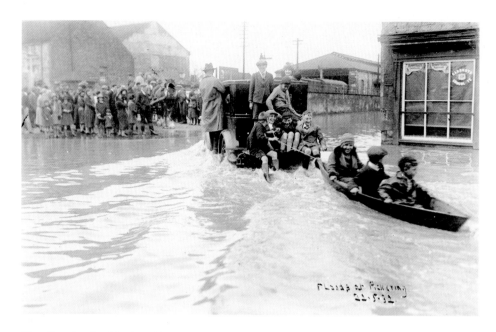

Flooding in the Market Place

Floods at the bottom of the Market Place, on 22 May 1932. Sydney Smith's car turns into Park Street, towing the home-made boat with three children in it, watched by a crowd of people on the left. Ryedale Travel have taken over Arnett's cake shop and café on the right. Railway notice boards mark the end of the North Yorkshire Moors Railway line, where a wall has been built to replace the level crossing into Bridge Street.

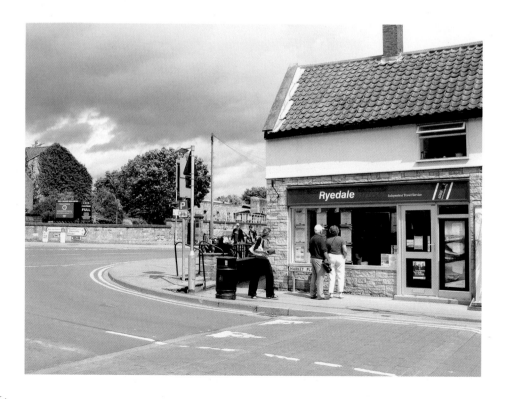

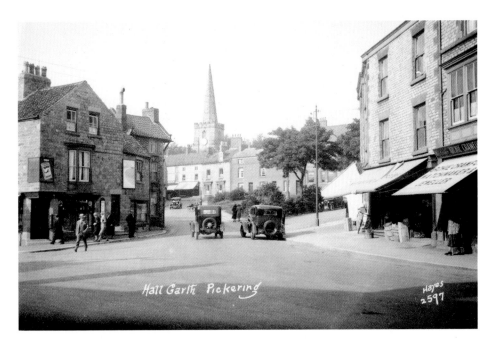

Smiddy Hill

Looking up Smiddy Hill on the left, with the bottom of Hall Garth on the right. Archie Crawford's watchmaker and jeweller's shop, and Strickland's grocers can be seen next door. It was thought to have been taken between 1930 and 1932. The shop on the left has changed into a solicitor's office, while a bookshop, and barber's shop are changes that have taken place on the right.

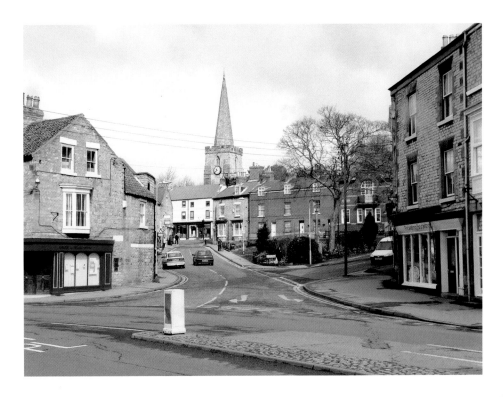

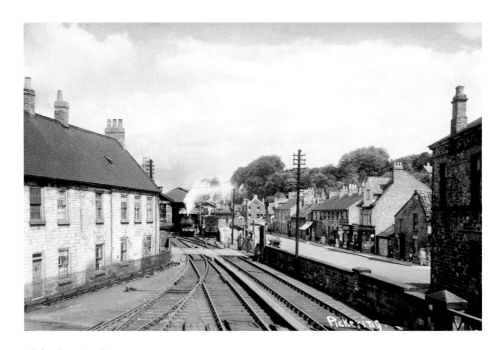

Pickering Station

A steam train is departing from Pickering Railway Station in 1933. The crossing gates in Bridge Street are closed to traffic. Railway cottages are on the left, and the Midland Bank and Park Street are on the right. Now the rail track in the foreground has been replaced by Ropery Road and the railway station has survived.

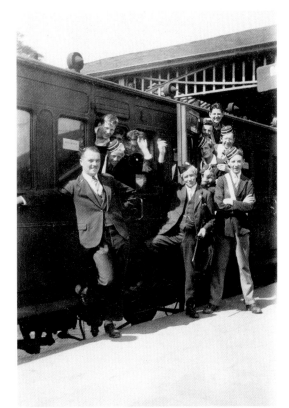

Railway Journey

Pickering Boys' Brigade board a train at the railway station for a journey to Scarborough in the 1930s. The two men are thought to be Lieutenant Bill Shimmin in the suit, and Captain Harold Markham holding a cane. Today the Moorlander *Sir Nigel Gresley* pulls into the station, as part of a steam weekend organised by the North Yorkshire Moors Railway.

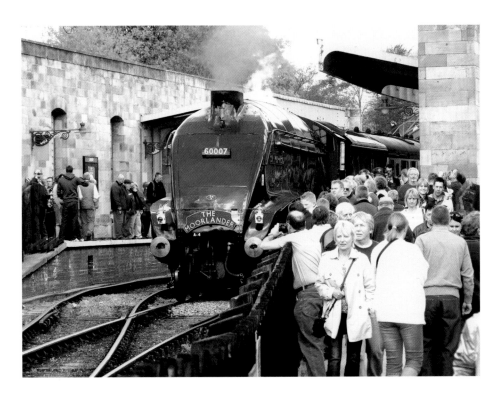

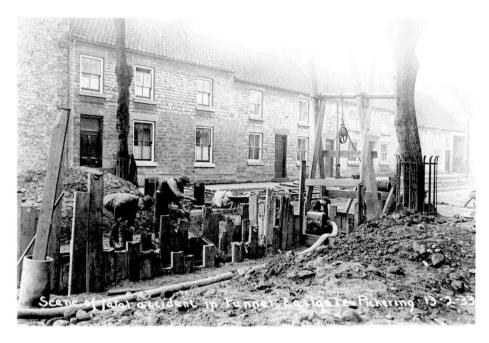

Scene of fatal accident in tunnel, Eastgate, Pickering 13-2-33

Disaster strikes

This was the scene of the fatal accident in Eastgate on the 13 February 1933. Robert Godfrey, a Rosedale miner, was crushed to death while tunnelling to lay a new sewer pipe in the road, as part of the new sewage scheme for the town.

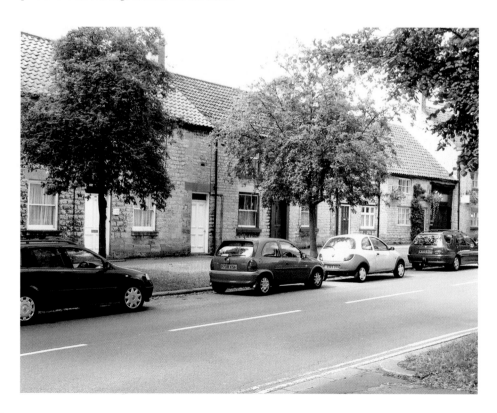

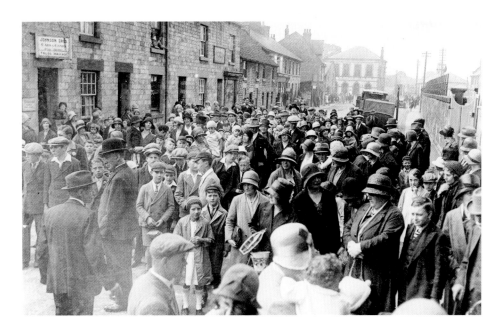

Sunday School Outing

The Potter Hill church group are about to start their Sunday School outing from Pickering Railway Station to Scarborough by train in the 1930s. Today the North Yorkshire Moors Railway organise their annual War Time Weekend, with a parade of old military vehicles, and the town's streets fill with people dressed in clothes and uniforms from the Second World War. Here a tank is driving up Park Street.

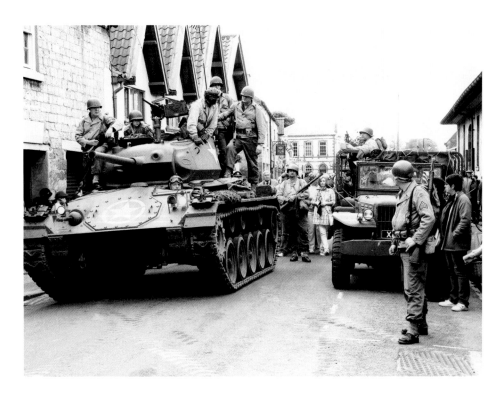

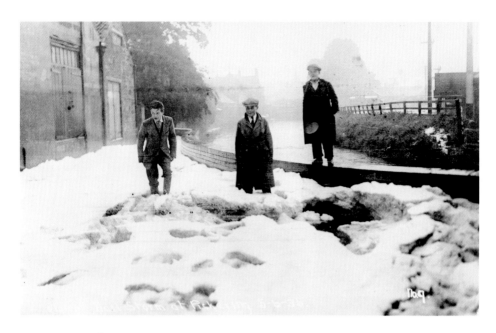

Summer Weather

Following a violent hailstorm on 5 June 1935, workmen from the town's urban district council had the job of clearing the streets. The workmen are standing at the side of the Midland Bank, at the bottom of the Market Place. On the same day the local grammar school was holding its sports day, which had to be cancelled. The railway goods yard has been replaced with the Ropery car park, and public toilets have been built on the right.

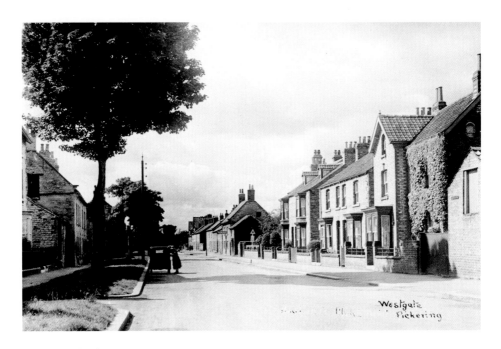

Westgate in the 1930s

One car is parked on the left, while the Sun Inn can be seen on the right. The building on the extreme right has now gone, but the only other major change is the amount of traffic using the road.

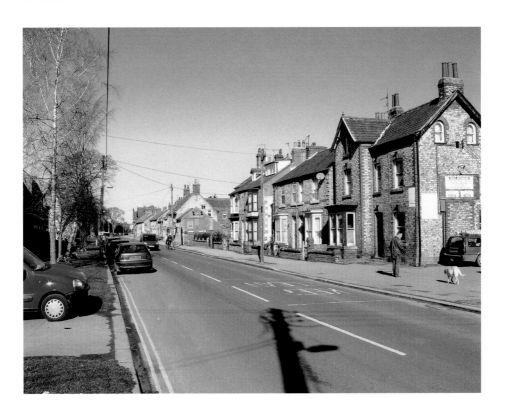

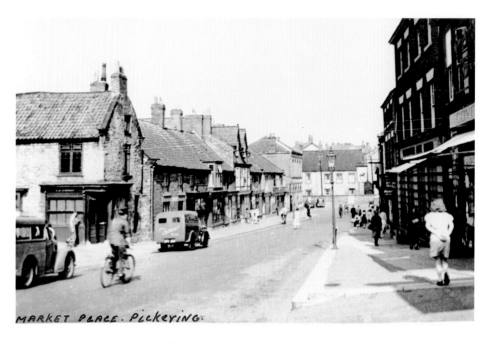

MARKET PLACE. PICKERING.

The Bottom of the Market Place

Sellar's butcher's van is outside the shop on the left, while Coverdale's boot and shoe shop can be seen on the right. The butcher's is now a charity shop, and Coverdale's has been transformed into a wine bar.

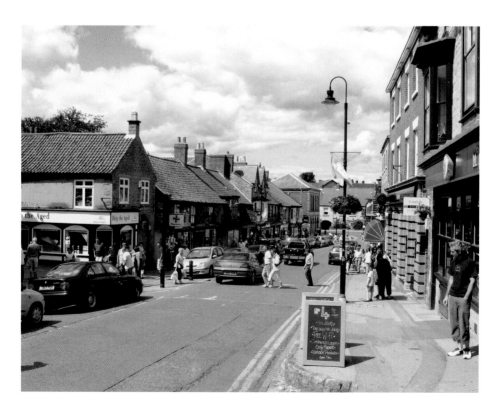

The Paragon Stores in Birdgate
For many years this shop sold
tobacco on the left-hand side, and
sweets on the right. Several different
owners later, all the cigarette signs
have gone, and the shop now sells
leather belts and guns.

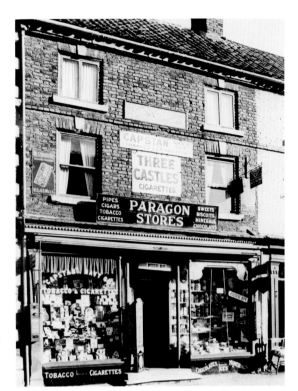

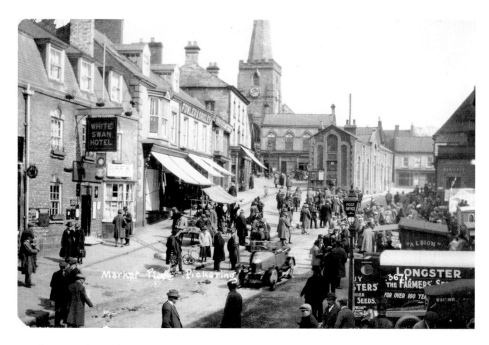

Market Day in Pickering
Little has changed from this photograph taken in the 1930s, apart from the names of the hotel and shop owners, and the demolition of the Vaults in the centre.

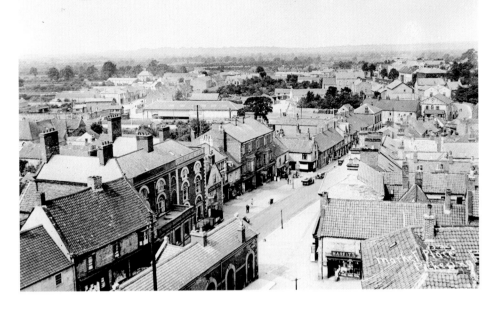

Market Place from the Church Tower

This view of the Market Place was taken by Sydney Smith from the Church tower. I took the same view on 20 April 2009, which just happened to be market day. The removal of the Vaults in the foreground has opened up the area, but most of the Market Place remains mainly unchanged.

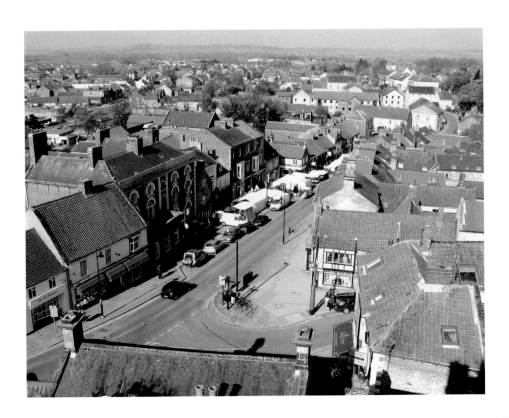

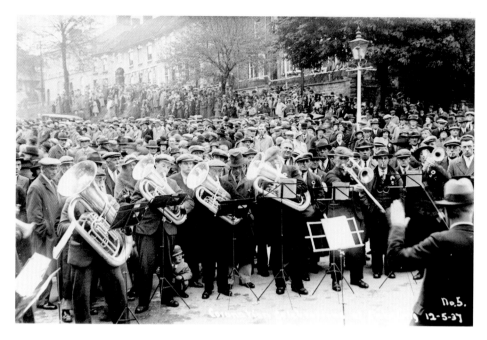

Pickering Town Band

The band play to the crowd on Potter Hill, as part of the celebrations for the coronation on 12 May 1937. The band was formed on 17 May 1936. Some members purchased their own instruments, but it took two years before each member received a new uniform.

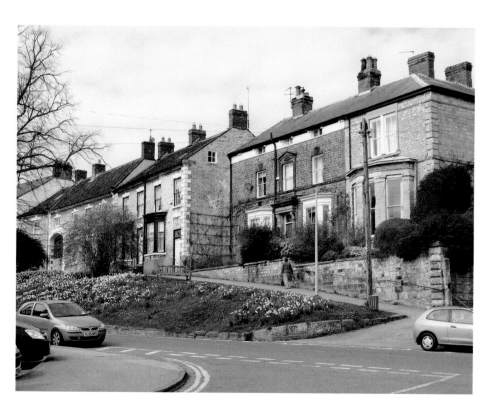

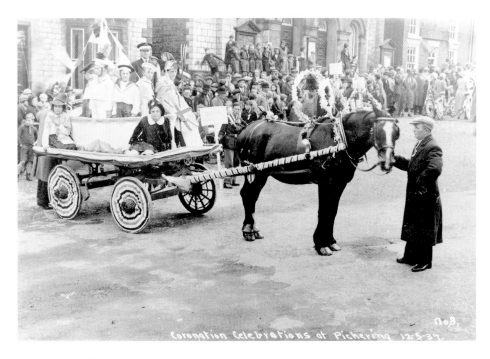

Coronation Celebrations

These took place on Potter Hill, 12 May 1937. The decorated horse and rulley would be ready to join the procession through the town. The man holding the horse is Hector 'Gow' Pickering.

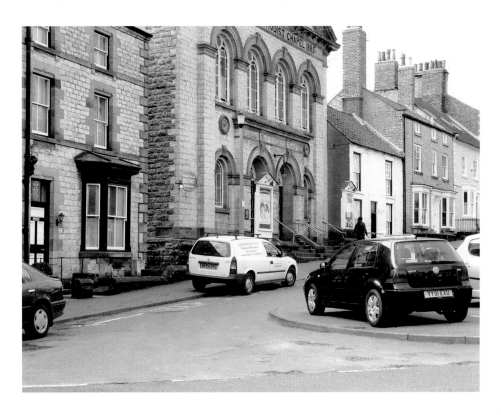

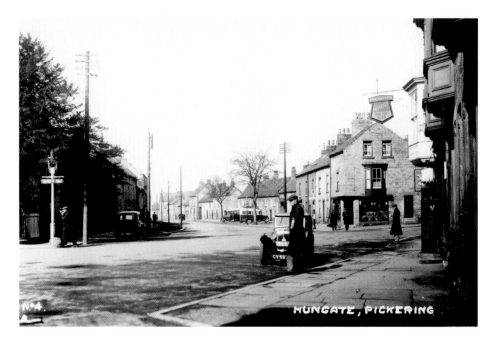

Hungate

Large trees grow behind railings outside the Low Hall on the left, later to become the Forest and Vale Hotel. Two buses are parked up in the centre, and a petrol pump can be seen on the right, in front of the entrance into the Horse Shoe Garage. Today a roundabout has been built on the left, and railings erected to protect pedestrians from the passing traffic.

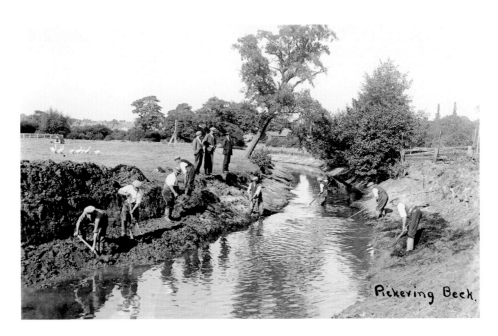

Pickering Beck

Council workers are cleaning out Pickering Beck, in what was known as Gas House Field in Mill Lane. In order to enable the work to take place, the two sluices at the side of the weir were opened to drop the water level. This undertaking no longer takes place, also one sluice is closed and the other has been replaced with concrete posts forming a dam. The full length of Pickering Beck passing through the town has been designated as a main river by DEFRA, and is managed by the Environment Agency.

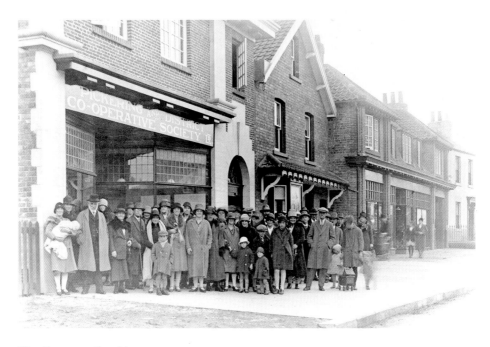

The Co-operative Stores

On 20 October 1938 the Co-operative movement expanded by opening their drapery department and offices in Southgate. The grocery department on the right opened in 1915. The movement was formed in the town in 1898, when fifty-six men subscribed £65 in share capital. The first balance sheet recorded sales of £1,196. There was also a shop on Potter Hill, at the junction with Train Lane.

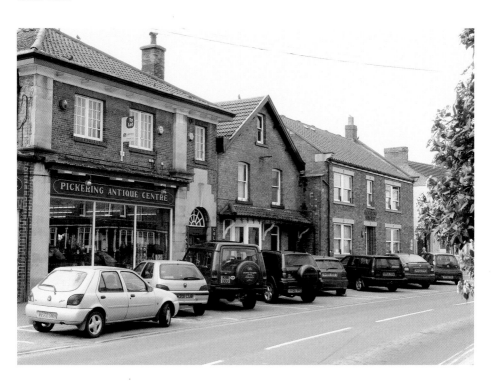

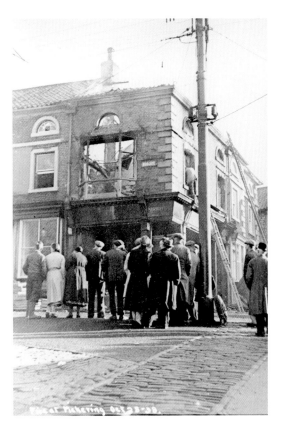

Shop Fire

This crowd of people are watching firefighters at work, fighting the fire at Roger's Nurseries shop at the corner of Burgate on 28 October 1938. The shop is now a café and restaurant, with tables and chairs outside.

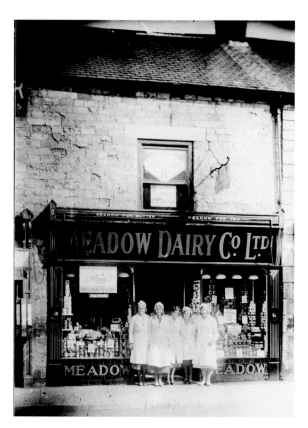

The Meadow Dairy Shop

This photograph was taken at the bottom of the Market Place in 1940. Lillian Weinner is thought to be on the left. Now it is named the Ginger Pig, and is a grocer's and butcher's shop, but is about to close.

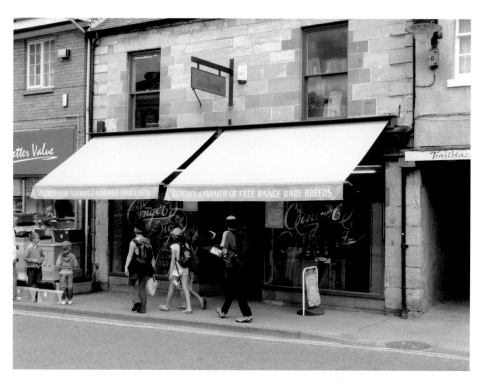

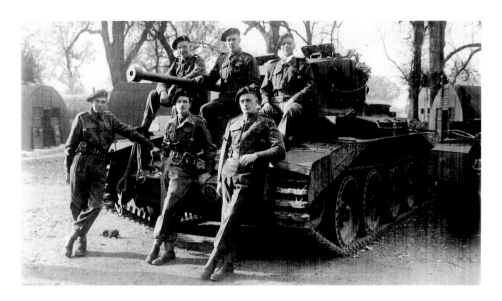

Preparing for War

The famous artist Rex Whistler poses with his tank crew at the Castle Camp. He is in the middle of the front row. In May 1940 he joined the Welsh Guards, who were armed with Cromwell tanks. Soon after this, the guards moved into the Castle Camp, but the officers were billeted in the homes of local families. Rex carried out several paintings in the town, some of which have survived. On Christmas Eve 1943, the guards organised a children's Christmas party in the Memorial Hall, and 294 children attended. Rex painted two large Welsh Guardsmen for the party, which can still be seen inside the Beck Isle Museum. At the beginning of May 1944 the guards left the town for France, and on the 18 July 1944 had its first encounter with the enemy, and unfortunately Rex Whistler became their first fatal casualty. Today an American army tank enters the railway station, taking part in the railway's annual Wartime Weekend.

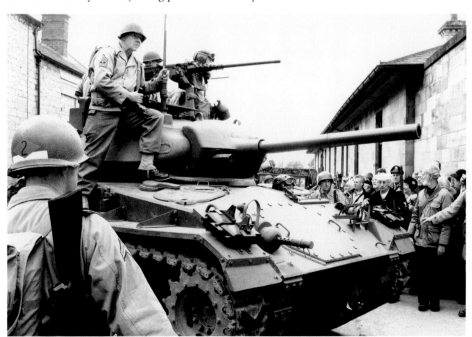

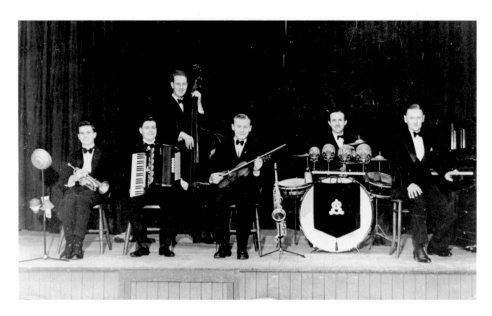

Arthur Smith's Dance Band

The band is seen playing in the memorial hall in 1946. It is thought that they were playing at a police ball. The band members are, left to right: Derek Hey (trumpet), Pat Wilson (accordion), Louis Creighton (bass), Louis Smith (son of Arthur, on violin and saxophone), Steven Welford (drums and xylophone), Arthur Smith (band leader, on piano). Arthur was known affectionately by his nickname 'Tweezer' to the locals in the town. The Chicago Teddybears Society Jazz Band play in the memorial hall at the 22 Pickering Jazz Festival on 21 July 2009.

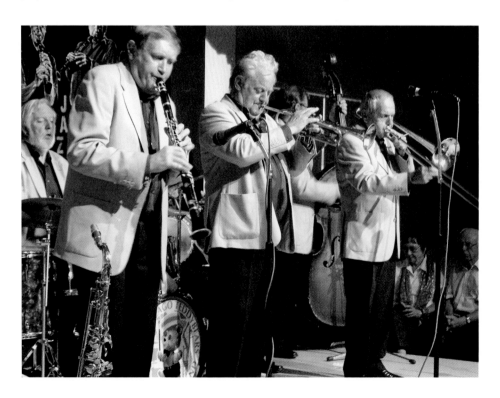

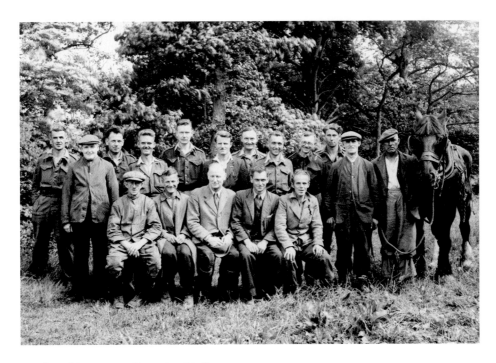

Duchy of Lancaster Forestry Staff

The staff worked from the depot at Newbridge, north of the town, and posed in June 1947. The men are, back row, left to right: Wilf Sollitt, Dick White, Peter Dalton, Albert Jackson, Ian Carr (trainee), Fred Gaines, Bill Farrow, George Sanderson, Wilf Stainsby, Charles Toes, George Allanson, Reginald Grimmer (horseman unknown). Front row, left to right: Walter Sellers, Stanley Hesp (? Duchy Estate Manager), Ian Reed (Head Forester), Bill Holmes. This is Lowther House at Newbridge. It was owned by the Duchy of Lancaster, and served as the depot for the duchy workmen.

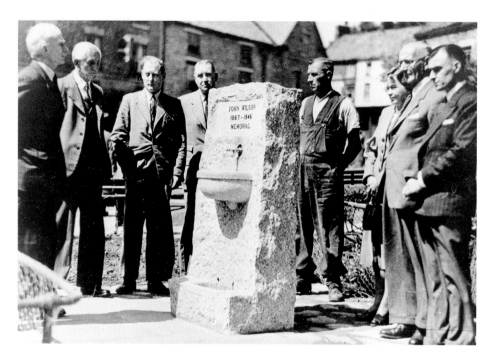

The Drinking Fountain

Official taking over of the drinking fountain on Smiddy Hill, in July 1950. It was presented to Pickering Urban District Council in memory of the late Mr John Wilson, a local Labour Pioneer. Left to right: Councillors Tom Taylor and Edward Warriner; Mr Gordon Batty (surveyor), Councillor Harry Brown, Mr Reg Harvey (council foreman), councillors Mrs Dorothy Hainsworth and Robert Dobson; Mrs Phillip Taylor (council clerk). The Fountain looks a little sad today as it is no longer operational, but it is still part of the Lumley Garden of Rest.

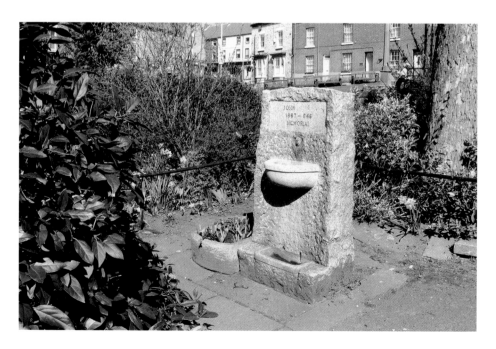

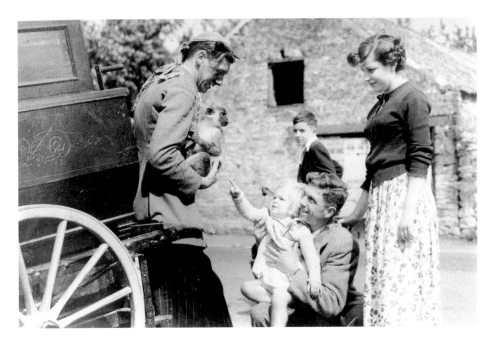

Pickering Carnival in 1952

Ernest Gibson with a monkey and a street piano is talking and showing the monkey to Jill Scales and her father Ron, while Nanette Emery, and an unknown boy look on. The photograph was taken on Malton Road. The building behind has since been demolished, along with cottages, and the police station, courtroom, and houses in Kirkham Lane. This work was carried out to allow for road widening, and the building of the new roundabout.

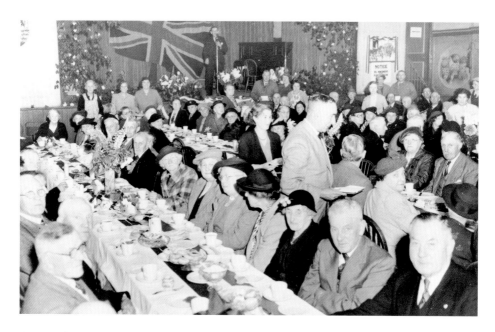

Coronation Day, June 1953

Senior citizens enjoy their party in the memorial hall. Captain R. G. Burton is waiting on tables. Some of the guests seated on the first table are Mr W. Maud, Mr W. Strickland, Mrs Strickland, Mrs Welford, Mrs Candler, Mr E. Burt. At the second table facing are Mr W. Hogarth and Mrs Hogarth. We can now see the entrance to the refurbished memorial hall, which was officially opened in 2001.

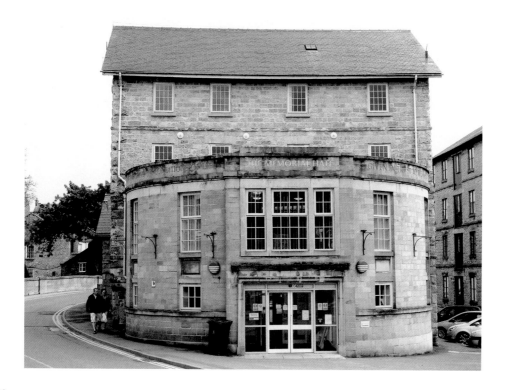

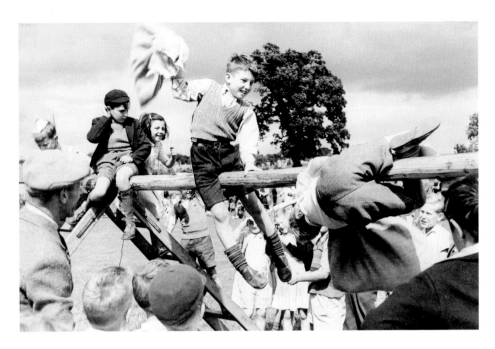

Pickering Carnival

This photograph is thought to have taken place in 1949. A pillow fight is taking place on a wooden pole suspended on trestles made from ladders, the idea being to knock your opponent off as quickly as possible in order to win a prize. The event took place in the recreation field. Note the large oak tree in the background. Members of Pickering Bowling Club play in a club competition on their club ground which is part of the recreation field.

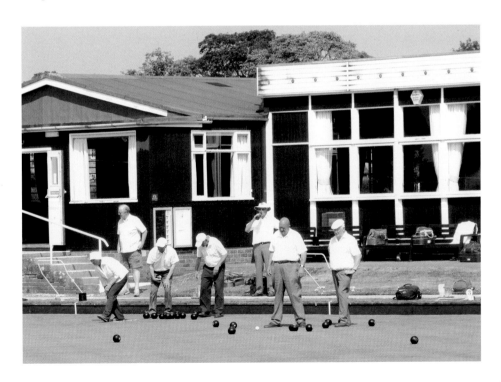

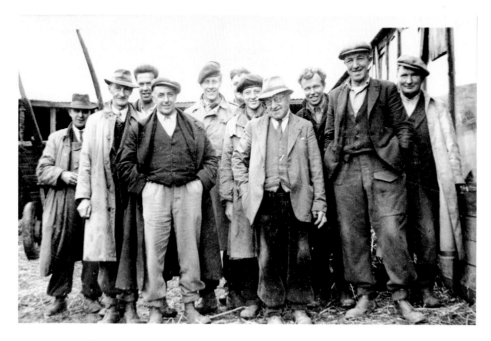

Nursery Workmen

Workmen from R. V. Roger's Whitby Road nurseries, taken in 1954. Left to right: Bill Martindale (foreman), Ernest Milner, Bill Davison, Bill Fletcher, Eric Hesp, Charlie Parnaby, Bob Hesp, Charlie Goodman, Harry Dresser, Jim Beaver, Noel Stead. Today modern dwellings and gardens cover the site. The road on the right is called Love Lane, which was used as the access into the nurseries.

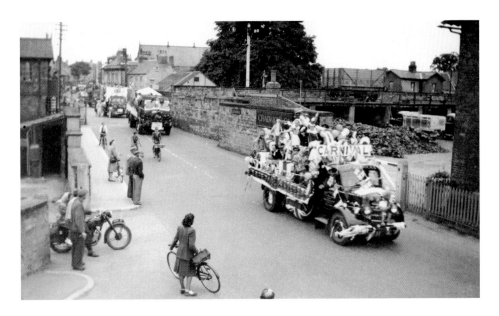

Pickering Carnival Procession

The parade of carnival floats pass Chadwick's coalyard in Southgate. A railway truck can be seen above the coal cells on the right. On the extreme right is the station master's house, and

on the left is the signal box that controlled the level crossing gates when railway trains crossed the main road. All have now been demolished. We can also see the removal of the coal cells and station master's house in 2008 before it had gone forever.

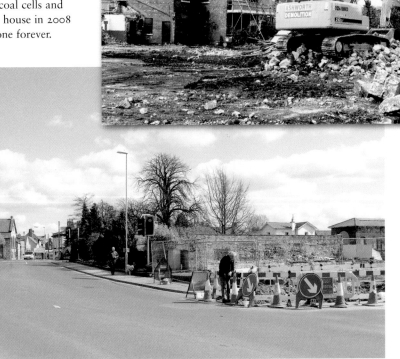

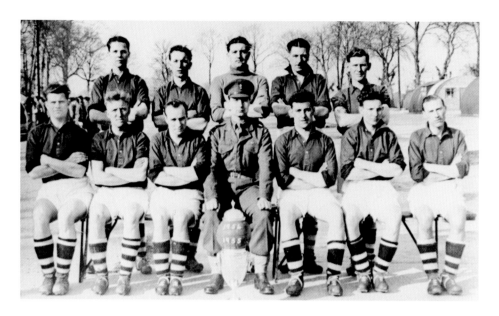

Guards Training Battalion Football Team

This photograph was taken in the 1954-55 season. The guards were based in the Castle Camp, now a residential housing estate. The player second from the left on the front row later joined the local police force. Danny Bailey became a chief inspector before he retired from the North Yorkshire Police Force. The Castle Camp was sold off for housing in 1965 and this is the site today.

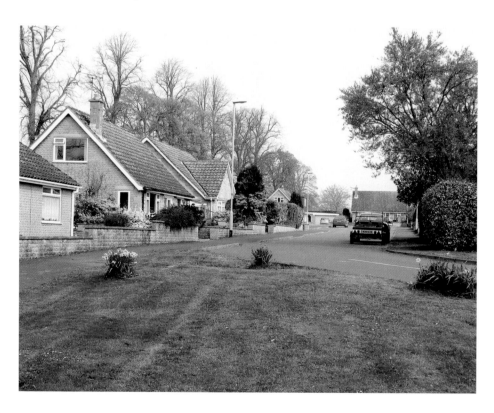

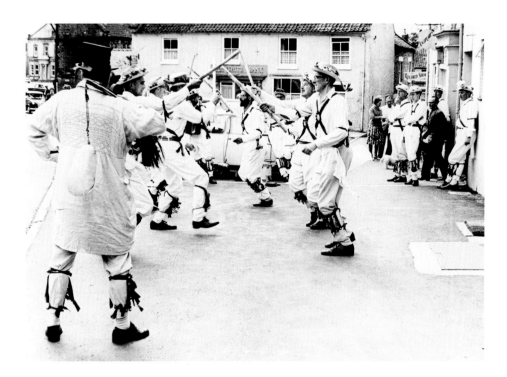

The Lettered Board

A group of morris dancers perform outside the Lettered Board public house on Smiddy Hill. Behind them is the Yorkshire Penny Bank, along with Mrs Pickering's cottage which can be seen on the right, and the public toilets on the left. Today a new bank building is in the centre, while the toilets have changed into a butcher's shop with a beauty salon above.

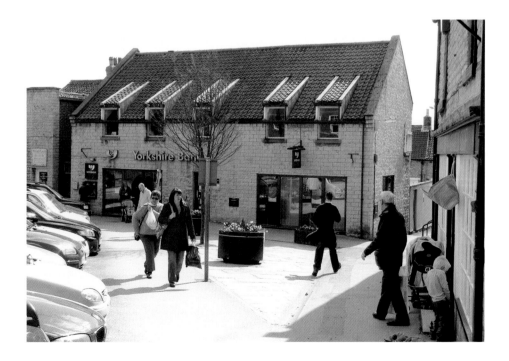

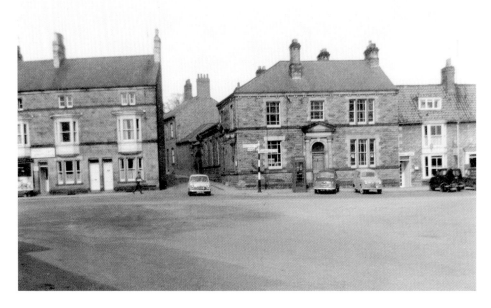

Kirkham Lane

It is hard to believe that this narrow lane was used as the road to Whitby. On the right is the police station and Burrell's Café (a former butcher's shop). Behind the station are the courtroom, holding cells, police house, weights and measures office, and a blacksmith's house, with the blacksmith's shop next door. All these properties have been swept away and a roundabout built in the foreground in the early 1960s, in order to widen the road.

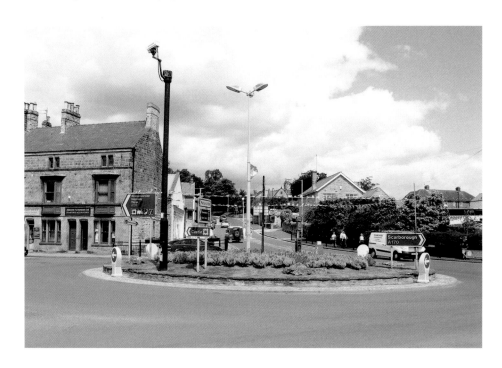

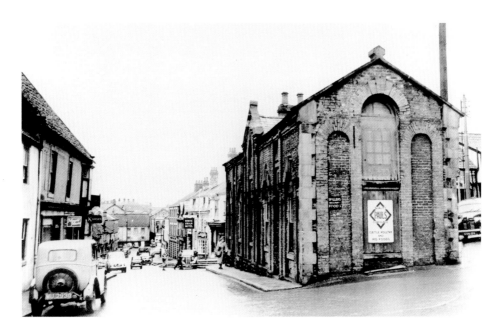

The Vaults

The Vaults standing at the top of the Market Place. By this time the building was being used as a corn merchants and a barber's shop. The Vaults were demolished for road improvements in 1958 after standing for ninety years.

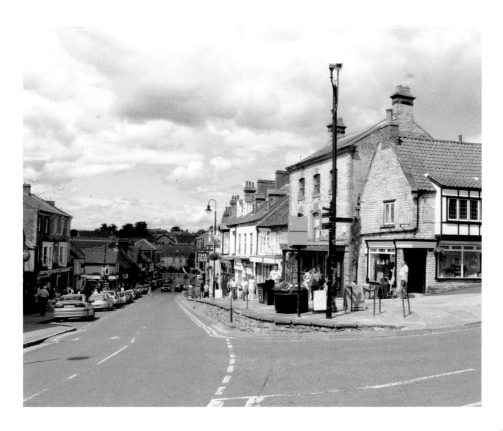

Acknowledgements

I would very much like to thank the following people for their help, advice and encouragement, and once again for their patience and good humour when I arrived at their doorstep. I also thank them for supplying me with information, identifying people and locations, and loaning me their photographs and postcards; and for making the many requests for 'just one more book'. I hope you think that our joint efforts have been worthwhile, and enjoy looking at the changing face of Pickering.

I would like to thank Barbara Sokol and her family for their continued support in my efforts to bring worldwide recognition to the work carried out by her brilliant photographer parents Sydney and Maud Smith, who spent most of their lives recording the changing life of Pickering and the surrounding area. I have shared with you a further selection of their photographic record. I would also like to thank the trustees and management committee of Beck Isle Museum in Pickering, for their encouragement of the changing displays of photographs from the Sydney and Maud Smith collection inside the museum; and to John Rushton for his foresight in starting the museum and the part he played in gaining the Smith Collection of photographs, plus his friendship to myself. Also the following;

Craig Cooper, Lee Taylor, Mrs A. Lax, Mrs Peggy Frank, John Addyman, Mrs M. Hutchinson, Mrs J. Gaines, Miss M. Harvey, Ron. and Margret Scales, Harry Dresser, Terry Shipwright, John Hunter, Miss B. Aconley, Alan Raw, Mrs K. M. Kershaw, Mrs F. Hardy, Keith Anderson, David Billett, Sid. Woodhams, Debbie Wright, and anyone else that I have accidentally omitted. I can only hope that they are proud that together we have presented a enlightening slice of Pickering history.

Copyright: The photographs are the copyright of G. Clitheroe and the trustees of Beck Isle Museum, and Barbara Sokol, daughter of Sydney and Maud Smith, and her family.

PICKERING THROUGH TIME

The beautiful old market town of Pickering has undergone many changes in its long history, making it the tourism haven it is today. The most important events have been the building of the stone castle overlooking the town, and the parish church with its majestic spire, and more recently the arrival of the railway company. In the last sixty years many of the old trades and industries have been replaced with new housing estates and modern businesses, which has allowed the population of the town to grow.

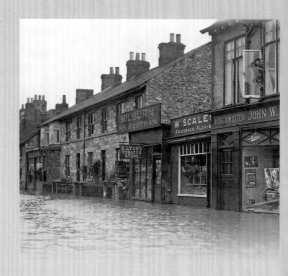

This fascinating selection of more than 180 photographs traces some of the many ways in which Pickering has changed and developed over the last century.

The reopening of the North Yorkshire Moors Railway, and the opening of the Beck Isle Museum as well many sporting facilities, has increased the town's popularity, mainly because its unique character has remained unchanged. This is a fascinating record of some of the changes that have taken place.

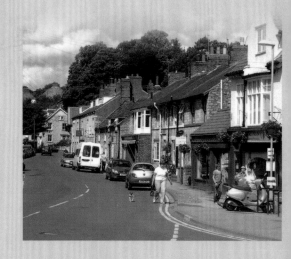

www.amberley-books.com

ISBN 978-1-84868-551-2

9 781848 685512

AMBERLEY PUBLISHING

£12.99

Amberley Publishing Plc, Cirencester Road, Chalford, Stroud, Gloucestershire GL6 8PE